PHOTOGRAPHING YOUR HERITAGE

Wilma Sadler Shull attended an Ansel Adams course, "Images and Words," held in Yosemite, California, in 1971. She is to be seen to the right of Mr. Adams, in straw hat and striped slacks. Mrs. Shull also attended the Brownville School of Art, adult education classes, and workshops in local schools and colleges. Apart from this training, books and magazines have been her teachers in the fields of photography and art. Mrs. Shull has won numerous awards in photography and painting, and her work has been published in the *Omaha World Herald*, the *Lincoln Journal*, the *Norfolk Daily News*, and the *Grand Island Independent*. Her photographs and paintings have been exhibited at local and state exhibits, the Jocelyn Art Museum in Omaha, the Sheldon Art Gallery in Lincoln, the Stuhr Museum of the Prairie Pioneer in Grand Island, and in the purchase-award collection of the Nebraska Arts Society now housed in the Nebraska Arts Museum in Kearney, Nebraska. She is a resident of Grand Island, Nebraska.

Photographing Your Heritage

WILMA SADLER SHULL

Ancestry Publishing
P.O. Box 476
Salt Lake City, UT 84110

Library of Congress Catalog Card Number 88-70335
ISBN Number 0-916489-31-0

First Printing 1988
10 9 8 7 6 5 4 3 2 1

Printed in the United States of America

Contents

Introduction

Using a camera is similar to changing clocks for daylight savings time. Once you learn to spring forward and fall back, it's simple. That is, if you don't get confused. Photography can be a great asset to those doing genealogical and historical research. The real problem in convincing others how to use a camera as a genealogical tool lies in putting the idea into words – the right words. I'm sure that your main interest in learning how to use a camera more efficiently is to improve the quality of your photographs and to make your family's history more interesting and complete.

The aim of this book is to help you to accomplish that goal and to give you only the information that I believe you will need in order to complete the tasks involved. I also believe that the readers of this book do not want to be overwhelmed with detail or bogged down in technical instructions. They do not wish to wade through mind-boggling words, which are for the technically minded. I know that I don't! In the first place I do not have a scientific, mathematical, or algebraic mind. I just want to take pictures. In the second place, why bother with evaluating aperture/shutter combinations or computing lens-to-subject ratios if you don't have to? Few of us will ever aspire to becoming a professional photographer or a darkroom genius, but a basic understanding of cameras and photographic processes is a must and will eliminate much of the confusion as you learn. Confidence and competence will come with experience.

A certain amount of experimentation is necessary. There are times when you must trust to luck and instinct. After all, "experience is the best teacher," and "trial and error" did not hurt Benjamin Franklin and Alexander Graham Bell too badly. Many of the cameras on the market

can be operated without bothering your brain. At the very least, you can put your thoughts on hold.

Acknowledgements

To my family and friends, who have encouraged my endeavors and have given me support or who did not object to my neglecting household duties, I offer my loving thanks.

Most of all, I wish to thank my friend Catharine Parish for the unbelievably difficult job of correcting my mistakes. Her great job of proofreading, advice, and "English teacher" admonitions were just what I needed. She pointed out to me how often I used the word "great" in my manuscript. Good job, Catharine!

Illustrations

All photographs are reproduced from the author's personal collection with the exception of figure 5, reproduced from *Nikkormat Instructions,* published by Nippon Kogaku (U.S.A.) Inc. The line drawings are by Kris Peterson.

1
The Genesis of My Genealogy Bug

In the beginning . . . I was a shutterbug. Nothing spectacular, but I had a good time being one. That stage of my life started in the eighth grade and grew along with me. It laid dormant during times of world crisis when film was unavailable, and, later, it appeared spasmodically during holidays and children's birthday festivities. I started getting serious about photography when no one in the family needed diapers or bottles, and became a shutterbug in full bloom at the birth of my first grandchild. I learned about f-stops and filter factors and filled up the house with photography magazines, a ton of slides, and all kinds of photographic paraphernalia. I read everything about photography I could get my hands on and remembered almost everything I could understand.

I am convinced that most of the people who write books and articles on photography would rather impress the professional reader than instruct the amateur. Why else would someone devise such terms as accutance, spherical and chromatic aberration, achromatic and anamorphic lenses, dichroic fog, refractive index, hyperfocal point, halation, and diopter? *Also*, did you know that light is measured in degrees Kelvin, a scale by degrees of color temperature? While germane, just how important are these facts to your work in genealogical photography? Although I usually practice what other photographers preach, I often use the same by-guess-and-by-gosh methods that I use in cooking. I hate to follow recipes so, as soon as I feel I know enough to be on my own, I follow my instincts.

I became vulnerable to the genealogy bug about the time my fourth child, a son, started to shave (whether he needed to or not). I was look-

ing at the pictures of my ancestors and began to see them in a different light. I wondered, "What kind of person was this who had such an interesting face and gentle eyes?" I wanted to know more about the people in the photographs. As my curiosity grew, my ancestors began to assume form and substance. Genealogy became a passion with me when I came to realize that my ancestors had personalities. The one-dimensional images became real-life people. Photographs do indeed enhance a genealogy. A family history book would not be complete without them. I am very fortunate that I have so many pictures of my ancestors.

After the genealogy bug bit me, my past hobbies fell by the wayside or became sidetracked for long periods of time. Quilting, painting, photography, writing, and collecting had occupied my time and were satisfying creatively. I enjoyed those hobbies, but genealogy makes me feel that I am doing something more important – something I wish I had started doing when I was very young so that I would have had many more years in which to enjoy the pursuit of discovering my ancestors. Perhaps I would have been young enough to have had grandparents living, and I could have asked them many questions. It does not disturb me greatly that many of my friends and relatives consider my efforts a waste of time. I feel that they do not know what they are missing, much as a person who has never tasted chocolate.

High school photography classes and adult education courses taught me basic photography and darkroom techniques. The Brownville School Of Art in Brownville, Nebraska, and a two week Ansel Adams workshop in Yosemite, California, furthered my photographic education. I don't know if I was the only student Mr. Adams ever took to the hospital in his pickup (after I slipped on the bank of a stream and landed on a rock), but I may have been the only grandmother with a cracked coccyx. At least, I can truthfully say that I went for a ride, alone, with this world-famous photographer, whom I considered a dear, sweet man.

Last summer I spent several weeks copying old family albums borrowed from cousins. The summer before that I copied many high school snapshots for a special "high school memories" album. My high school (Central City, Nebraska) was celebrating its 100th anniversary (not my

graduation class, mind you!). It would have cost a small fortune to have all those photographs copied professionally since there were hundreds. Many I copied several times as they were "problem photographs," faded and worn. The worst were the blackened, bent, scratched, and worn tintypes of my grandparents in their high school theatrical performances. Even those turned out remarkably well. As I copied the faces from the past, I thought that almost anyone could do the same. I wrote this book to prove that point.

2
The Camera: A Tool for Genealogists

Suppose you have traveled far to visit relatives who you have never met before. They show you a large box of old family photographs, which makes you turn green with envy. There are many cabinet photographs and several tintypes of your grandparents, great-grandparents, their brothers and sisters, and other family members.

They bring out an antiquated, dilapidated, family Bible with several pages listing the births, deaths, and marriages of the people in the photographs. The handwriting is quaint and faded. A framed marriage certificate and several large photographs hang on the wall of an upstairs bedroom. Two of them are of your great-grandparents and resemble charcoal drawings. Another is a photograph of a handsome young man in his Civil War Cavalry uniform. It is softly tinted with pastel in a gold, ornate frame. You had no idea of what he looked like until that moment.

Oh, how you envy those fortunate relatives! What treasures the old photographs are! Dare you ask to borrow them to have them copied? Do you have the nerve to ask that they have them copied for you? About the time you have prepared yourself to break the question, your host says, "We did have several more old photographs, but another cousin borrowed them and never returned them; and then I sent a whole bunch to some place in Kansas to be copied, and they got lost in the mail." Well, that took care of that! You know by the tone of the voice that you dare not ask. You say that you would like to take some pictures of a few of the most important ones. They do not object, and you pull out your disk camera. You haven't the slightest idea how to take close-ups, but you try. All you can hope for is good luck. You will probably need it.

1 I discovered a book containing pictures of a Shull coat of
arms and Mr. Frank Schull (pictured above). Though he is
not known to be related to my husband, this Mr. Schull
bears a strange family resemblance.

Another imaginary situation might be described as follows. You are
in a distant library. You cannot believe that you have been fortunate
enough to find so many wonderful books. They have an old, county land-
owner atlas that has your ancestors' names on the town lots, recording
the land they owned. There are beautiful engravings of their houses and

brief biographies. You take the books to the copier and find that it is so low on toner that you can barely read the copies.

Let's pretend that we are in another library, but this time the copier is working efficiently. You find a lovely book, a history of one of your ancestral districts. You didn't know it existed, much less that it would have so much information on your people. To top it off, there are photographs and engravings of your ancestors and beautiful family crests in gorgeous color. You are happily excited as you turn the pages and examine the wonderful contents. It was printed in 1883 and was recently rebound. It is more difficult to open than a warped door after a four-inch rain. You try to copy it on the copier, but it is so tightly bound that only half of the page is copied. What to do!

It is at times like these that cameras have saved my day. If you knew how to take close-ups, you could have photographed the pages of the atlas and the illustrations. Even though the pages in the rebound book could not be copied on the copier, the photographs and some of the most important pages could have been photographed with the book half open.

You could have taken color photographs of the coats of arms, and you would not have had to spend time writing descriptions of the colors. Someday you may wish to have a painting or needlepoint made from them, or you may be able to execute such work yourself.

Even when photocopiers are working as they should, a camera is better for reproducing illustrations and photographs. For those heartrending times when a photocopier is malfunctioning or nonexistent, you would, at least, have some photographs to show for your trip to distant ancestral resources. Suppose you have in your possession a great many old family photographs. Dare you send them away to a photo lab that does not charge nearly as much as the local camera shop? Do you dare risk entrusting them to the post? No, definitely not! They could never be replaced. You take those precious photos to the local camera shop to get an estimate but find that you can afford to have only a few copied. While at the camera shop you look at the camera equipment and wonder whether perhaps you could do the copying yourself. Indeed, you can!

3
Thoughts on Buying a Camera

The selection of the right camera and the right lens is very important, especially when they are to be used for close-up photography and copying. Before you entertain thoughts of buying a camera, you need to prepare yourself. Go to the library and check out books on photography, especially those that include information on close-up techniques and copying. Though some of the books may be out-of-date, basic photographic technique and principals have not changed that much. Study current consumer reports and photographic buying guides, which might also be found in your library. Examine books in book stores and select one as a reference guide. It should be complete in scope and should include a general summary of all aspects of photography. Thumb through the photography magazines on the newsstands to decide which cameras have features that appeal to you. Magazines often contain detailed reviews on new cameras. When you find a magazine that interests you, buy it and study the advertisements.

Advertisers often boast of a specific enhancement that is unique to their product, or their camera may do something better than others on the market. Periodically, camera makers battle each other in attempting to develop the perfect camera or the ideal format. There are always "here today, gone tomorrow" innovations, and gimmick cameras usually fall by the wayside to become collector's items. Tried-and-true features are retained and improved, and probably are here to stay.

Go to several camera shops to look at different makes and models of cameras. Browse, ask a lot of questions, ask for free literature, and do not be persuaded to make any binding decisions. Avoid being influenced

towards or touted into deciding upon a camera that might not be right for you. Explain what your needs are and how you intend to use your camera. A reliable salesperson will offer suggestions for your consideration; however, keep in mind that salespeople may be neither authorities on cameras nor competent photographers. They should demonstrate a camera's features and show you how to use them. Do not pay for extras you will never need or use. Why pay the price for a camera capable of shutter speeds of 1/4000th of a second if you have no interest in photographing a humming bird's wings in flight or a bullet speeding through the air. Likewise, why select a camera that is not capable of doing everything that you want it to do? Camera lenses also have "speeds." A fast lens capable of low light interior shots is more expensive than its slower counterpart and may not have the necessary quality.

The camera you buy does not have to be the most expensive or the one with the most automatic gizmos. In fact, it does not even have to be new. There are many good cameras that have been traded in for those with newer features or more automation. Ask for some kind of guarantee and you might get it. Don't buy unless you have faith in the dealer. Be assured that the camera is in good working order and that the lens is satisfactory for your use. Ask a lot of questions. When was it made? Are accessories and additional lenses still available? Avoid the obsolete and unfamiliar brands, unless the camera is exactly what you want and the price is right. If the lens alone is worth the price, you can always buy a new body for a quality lens at a later time.

Some important considerations in purchasing any camera are:
1. What will this particular camera do for me that other cameras cannot?
2. Will this camera do everything I want it to do both now and in the future?
3. Has this camera a reputation for reliability and performance?
4. Will I use a particular feature often enough to warrant its additional cost?

Amateur Versus Professional

When you are camera shopping and studying the advertisements you may notice the phrase, "Professional photographers prefer...." Don't let that phrase fool you! Amateurs might also prefer those features if they knew what they were and how to use them. Such features may be just what you want on a camera, and there is no reason why you cannot learn how to use them. Almost anyone can learn to operate almost any camera, so do not be influenced into purchasing a camera because of "ease of operation."

Some of the well-known camera makers produce camera bodies especially for professionals. The main difference between a professional model and those designed for amateurs is that the professional camera is usually a "no-frills," heavy-duty body made for rugged wear. Its internal parts are made of metal, instead of plastic, in an all-black body devoid of chrome trim. Professional photographers do not want a lot of chrome to reflect light and announce the presence of another "photo-hobbyist." They wish to remain as unobtrusive as possible. An amateur finds chrome trim attractive, and their cameras are designed to be replaced, or self-destruct, after a certain amount of film has been shot.

There has always been controversy in the arts about the definition of an amateur and a professional. In the field of photography the dividing line between a serious amateur and a professional is sometimes difficult to define. Aside from the obvious difference of making money, the differences may be expressed in:

1. Education
2. Experience
3. Enthusiasm
4. Expertise

The gap between amateur and professional photographers narrows when an amateur expands into the four E's. The advanced amateur may know just as much, or more, about photography as do some professionals, but it is reserved as a hobby – something that offers a tool for creativity. A camera may spark an appreciation for nature's beauty, offering a challenge to capture that beauty on film.

Many amateur photographers would like to take good pictures but do not want to "fiddle" with complicated and confusing controls. The average amateur wants a camera that will do everything automatically. A serious amateur does not want a lot of complicated calculations either but selects less automation and more personal control. The serious photographer desires to improve his picture-taking abilities, and reads how-to books on photography. He experiments, perfects techniques and keeps on learning. Most of us will never become knowledgeable about every phase of photography, yet each of us can become more proficient in the use of a camera; and, no matter what kind of camera we use, we can learn to use it better.

Types of Cameras

The camera that you now own, or may purchase in the future, is probably one of two types: the simple camera with automatic settings, or a 35mm single-lens reflex with more options, special features, and a choice of lenses. The ultra simple cameras that you may have been using are fine for ease in carrying and are available at a moment's notice. There is nothing to do with such a camera but point and push. I use them myself. Small, simple cameras can take good pictures, but they cannot compare with those that produce larger negatives. In order to make a print of a decent size, tiny negatives must be enlarged greatly. Everything that makes a camera conveniently simple is a minus for serious use. The simple cameras are not meant for the business of specialized photography, so reserve them for your casual use.

Cameras are classed by the type of viewing system and the size of film they use. There are two general kinds of viewing systems, rangefinder and single-lens reflex (SLR). There are variations on both basic types, which include view, press, twin-lens, sports, instant (Polaroid), and others. Professional and serious amateur photographers use SLR and twin-lens cameras requiring 120 or 220 roll film, or view cameras, which use even larger sizes of sheet or roll film. Cameras requiring a larger film format can also be used for close-ups and copy work, but they and their lenses are more expensive, and the film cost per picture is higher. Profes-

sionals use the larger film sizes because larger negatives yield better picture quality and offer greater enlargements. Professionals use and enjoy the features of 35mm for the same reason as you or I – because of its convenience and economy. Thirty-five millimeter film is available almost everywhere. It will produce better pictures than will smaller format sizes, such as disk and instamatic.

Rangefinder Cameras

A rangefinder camera has a pre-set, or fixed-focus, lens that includes only the subjects within a certain range. Some compact rangefinders have lenses that are non-focusing. Others have a limited range: near, average, and far. The nearest focusing distance is not sufficient for close-ups and a supplementary lens attachment must be used. Within a rangefinder camera's viewer is the outline of a rectangle. This is the area that your photograph should include. There may be another rectangle, or the four corners of another rectangle, that is used when taking close-ups. Within the viewfinder area there may also be symbols, or outlines, of figures, groups of people, or mountains. When the camera's lens is focused, a symbol appears in the finder indicating the distance covered at that setting. This defines the limits of focus for that particular camera's lens.

Rangefinder cameras include compacts, instamatics, disks, and most simple cameras. A rangefinder camera has a viewing lens in addition to its picture taking lens. What is seen through the viewer is approximately the same as what the taking lens sees – except that at close range there is a problem of parallax correction, a correction needed when the camera is used at a range closer than that for which the lenses were designed. The eye is not able to judge accurately how much of the subject seen in the viewfinder will actually appear in that photograph. The rangefinder camera is unsuitable for serious close-up photography because the eye cannot see exactly what the picture taking lens sees. Pictures may be lopsided, or portray people with heads chopped off. There may even be people missing from a group because the photographer's eye thought they were there. What good is a picture of a family reunion if half the family have half their heads missing, or are missing altogether? Several

surprises may be accounted for because the subject is viewed through one lens and the picture is taken through the other. Camera straps, fingers, and other unaccountables have shown up in photographs. Some cameras will not operate with the lens cap in place. As for those that do, a great number of perfectly flat pictures have been taken of the reverse side of the cap. But please bear in mind the importance of the lens cap. Failure to replace it after using your camera can result in damage to the lens and an adverse effect on the quality of your photo image.

Another thing that contributes to viewing errors is the distance between the eye and the viewfinder. Eyeglasses can be a problem even with single-lens reflex viewing. Your eye needs to be as close as possible to the eyepiece of the viewer and not off to either side. Take time to compose your subject, and if you can see all sides of the viewfinder's window, you should be OK. Viewing and focusing systems vary, and you may prefer one camera's viewfinder to another. Do look at several makes.

Rangefinder Versus Single-lens Reflex

The 35mm camera can be either a rangefinder or a single-lens reflex (SLR), depending on the type of viewing system incorporated into the camera. The SLR is the camera of choice because of its reflex viewing system and the wide selection of interchangeable lenses and accessories available for it.

The Single-lens Reflex

The single-lens reflex camera has a complex viewing system of mirrors that bounces the image through the camera lens, into the mirrored reflex housing, or pentaprism, to the eyepiece. The SLR viewing system is the most accurate; therefore, it is essential for many photographic procedures. The viewing is sometimes referred to as WYSIWYG (What You See Is What You Get). Some cameras have a removable pentaprism, which is an asset in taking close-ups and copying. Focusing can then be done on the camera's ground glass, or a waist level viewer can be inserted, which reverses the mirror image. A 35mm camera with a waist level

viewer can be placed on the ground and focused on an object such as a golf ball without the photographer having to resort to standing on his head to take the picture. The photographer looks down into the focusing system rather than through the pentaprism.

Some SLR cameras also have the advantage of interchangeable focusing screens to aid the eye in focusing various lenses. There are screens designed for special applications such as close-ups and copying. These interchangeable features are highly recommended, especially if you intend to use a macro lens to any extent.

Eyeglass wearers sometimes have difficulty in focusing because of various eye corrections and an inability to get close enough to the camera's viewing lens. Such problems may be corrected by an optometric

2 Through-the-lens metering: light passing through the lens activates an internal meter.

lab. An optometrist may be able to fit your camera's viewer with a correcting lens so that you can see to focus the lens without wearing glasses.

Most modern SLR cameras have some type of through-the-lens (TTL) metering system. Such metering is very accurate and very convenient. However, there are times when it is necessary or desirable to override TTL metering, so be sure to purchase a camera that will allow

this option. TTL metering is one of the features I would not be without.

Single-lens reflex cameras generally have more than one mode of operation. There are shutter-preferred, aperture-preferred, manual, and automatic or programmed. In the shutter-preferred mode you select the shutter speed to be used, and the camera determines the amount of light needed to make the proper exposure. This is advantageous to the sports photographer who must stop action with a fast shutter. In the aperture-preferred mode you select the aperture, and the camera determines the necessary shutter speed. The automatic, or programed, mode selects both the aperture and shutter speed. In the manual mode, you are "in the driver's seat." You can choose whatever shutter speed or aperture you wish depending on your needs. You can have complete control, and this is often necessary as there are many times when fingers are best.

System Cameras

The lenses and accessories made by the camera's manufacturers are designed to be used on the cameras they make. Major camera manufacturers have "systems" especially designed around cameras made by, or for, that company. A system is composed of several bodies, many lenses, and accessories. The accessories include filters, lens mounts, strobes, close-up equipment, bellows, shutter releases, and almost everything you could ever want or afford.

With the exception of a few independent lens manufacturers who make less-expensive lenses for well-known system cameras, a camera lens made by one company will not fit a camera made by another. There are different kinds of lens mounts and they are not interchangeable with other brands unless a special adapter is provided. A systems mount generally has a better fit than one on a lens made by an independent lens company. This insures less wobble and quicker, easier lens mounting. A wobbly lens can lead to camera damage. It is best to use lenses and accessories within a camera's system. Even then there may be problems. Progress makes certain lenses and accessories obsolete. Be sure that all things are compatible before you buy.

History of Windham in New Hampshire 1719-1883 by Leonard A. Morrison. Cupples,
Upham & Company, Boston, 1883

3 Camera copies of engravings, using the macro lens. The illustration to the left includes the man's signature. That to the right has
been given greater magnification in order to include only a close-up of the portrait.

The Interchangeable Lens

The subjects that genealogists photograph are important historically, genealogically, and sentimentally. We want to capture on film the best possible image because we may never have the opportunity again. Just as a wildlife photographer needs a long telephoto lens, a genealogist needs a lens with the ability to focus closely; it must not distort line drawings, documents, or continuous tone photographs. A macro lens is ideal because it is specifically made for close-ups. It was designed to eliminate the curvature of field that occurs with normal lenses when they are subjected to focusing on a close-up subject. A straight line photographed at close range with a normal lens may appear curved. Lens distortion is detrimental in photographs of documents and photographs. A macro lens is slower than a normal lens, yet the lens versatility, performance, and convenience make up for the slight loss in speed. A macro lens is also more expensive, but it is well worth it. It can serve as your "normal," or general purpose lens. Many normal lenses do a fair job of moving in close, but the resolution and detail of a normal lens cannot compare with the macros. Quality varies from manufacturer to manufacturer, so inspect several makes.

Single-lens reflex cameras can be purchased with or without the 50mm normal, or general purpose, lens that is usually sold with the camera. If the company that makes the camera which you are interested in also makes a macro lens and you can afford the additional price, I would strongly advise you *not to buy the normal lens that comes with the camera.* If you intend to copy many old photographs, a macro is the lens you will need. Normal lenses need assistance to be used for close-ups, such as correcting lenses, tubes, extension rings, or bellows.

A macro lens can photograph an object 1/1. That means that you can photograph a stamp and the portion of the stamp photographed will be actual size on your negative or slide. If you do not buy a macro, instead of the normal, lens when you buy your camera you may be sorry, especially if you will be using your camera often in the close-up mode, such as rephotography. You may decide in the future that you cannot exist without a macro lens, and your normal lens will seldom be used. *Instead,*

buy the *macro* if at all possible. The 55mm macro will serve you well as an excellent normal lens. In addition it has the capability of close focusing for those ultra close shots. You can walk down a country road taking scenic pictures, and when a beautiful butterfly lands among the daisies, you needn't change lenses to capture the insect's image as large as life. The butterfly might fly away while you refocus, but changing lenses would be more time consuming and a bother when you are being creative. Yes, the macro, or micro, lens is more expensive, but it may be the only lens you will ever want. A micro lens is a macro; the meaning is the same. The Nikkon Company named their 55mm macro lens a Micro-Nikkor. It is my favorite lens, and one I have used as my normal lens for twenty-five years.

Another lens that is quite useful is the medium wide-angle. A wide-angle lens allows you to cover a greater "subject area" from a particular vantage point than would a normal lens. A wide-angle lens includes more of a subject (as if you were farther away) and a telephoto includes less subject area in your picture (as if you were closer to the subject). A wide-angle lens would help in photographing large objects from a closer distance, and would include more people in your picture from a vantage point than would the normal lens. The wider the wide-angle lens, the more subject is included in the photograph; *but*, as the lens widens, the subject becomes more distorted – the wider the lens, the greater the distortion. This curvature-of-field is disastrous in photographing people. We have all seen those television commercials in which the faces are horribly distorted. You would not need an extreme wide-angle lens for any type of genealogical photography unless you tried to photograph an entire cemetery, or an enormous family reunion, within a 35mm frame.

A medium telephoto such as a 90-120mm length lens is excellent for "people pictures" and portraits. Because you are at a distance from your subject you can catch an individual unawares resulting in an unposed, natural photograph. With a normal lens in the position to take a head-and-shoulders shot, the camera must be quite close to the subject; consequently, they might become uncomfortable or camera shy.

A "prime lens" is a lens that has a primary, or specific, purpose. A

normal lens, wide angle, or telephoto is a prime lens that has a limited focusing distance within a certain range. A "zoom lens" is not a prime lens but has a wider range of focusing distances, and can serve as a normal (plus) medium wide-angle or a normal (plus) short-telephoto, either of which varies in length and ability. This lens is able to zoom from one range to another and allows you to have the advantage of more than one lens within the framework of one lens. The quality, or definition, of a zoom lens is usually not as good as a primary lens from the same manufacturer. There are even macro-zoom lenses. For absolute quality, choose a prime lens.

Whatever lens you select, be sure to check its focusing distances before leaving the store. Compare the focusing ability of the macro lens to the lens that ordinarily comes with the camera. Actually measure the closest focusing distance with each lens. Walk around the camera shop and focus the lens on various items and for several distances. So what if you find people staring at you! You are only acting professionally. See if you have any difficulty in focusing or seeing within the viewer.

Star Wars *Cameras*

The *Star Wars* features of many of today's cameras are incredible. There are those that automatically load and wind your camera while others automatically set the film speed index. Some compute the amount of flash needed by measuring the light striking the film surface. There are auto-focus cameras that will focus upon your subject for you. Others will even talk and tell you either what to do or whether you have done something you should not.

Because today's cameras are sophisticated and capable of doing fantastic things, buying a camera is not a simple matter. More than ever before the camera buyer who desires more than a snapshot camera must have some knowledge of what a camera is, what a camera does, and how it does it. You don't have to learn all about f-stops (apertures), shutter speeds, and other operational functions, but such knowledge would be to your advantage.

Automatic film loading, transporting, or winding are all fine features.

Some cameras even set the film speed index. Setting the film speed index is one of those little things that you sometimes forget. On occasion I began to wonder, after blissfully clicking off frame after frame, whether the film was being transported through the camera. Sometimes it wasn't, and I had shot an entire roll of nothing. More than once I have sent to processors film that was never exposed. This was especially frustrating: all those carefully composed, fine focused photographs had to be done over again. There are times when an auto-wind, or power-wind, is desirable, but I prefer not to have one that is built into the camera's body. I would choose an auto-wind that is separate. I want to be able to operate my camera in case of battery failure. Such features take quite a toll on batteries. An auto-wind is especially helpful when your camera is on a tripod or camera stand and you are using a cable release. A cable release should be used whether you have an auto-wind or not. It is especially useful in conjunction with the auto-wind as the camera need not be touched when making several exposures of the same subject in the same location and there is less chance of camera movement. After you have focused your subject – and for as long as it remains in focus – you need not look in your finder. You can talk to your subject and watch for that special moment when your subject would make the best photograph.

One automatic feature that I have been able to live without is the auto-focus. There are times when it might be helpful, such as when light is poor and focusing the lens is difficult. The auto-focus sends out a signal that

4 Manual setting engraved on the camera's body.

strikes the subject and sets the lens focus automatically. This is fine, but when there are several subjects at various distances it may be difficult for the auto-focus to decide which subject to focus upon. Ordinarily, I would prefer to do my own focusing rather than to rely on a camera to do it for me. If you select a camera with auto-focus be sure you can override the feature when it is not wanted. For that matter I would not suggest a camera that will not allow you to override any of its automatic features. Be sure that the ability to operate manually is explained in your instruction booklet, and that there is a "manual" setting engraved on the camera's body among the multi-mode features. Whatever automated features you choose should depend on how important they are to *you*.

Buying a Camera by Mail

Cameras can be purchased at considerable savings from photography supply dealers who advertise in photography magazines. However, if you lack camera savvy, you would do well to buy locally from a reliable, respected dealer who will be there if you need him. If you decide to order by mail, clearly state "no substitutions" and be especially careful that you get exactly what you ordered. If you do not receive it as ordered or within the specified time as allowed by law, send a detailed complaint to the publishers of the magazine in which the ad appeared. Keep photocopies of all correspondence. If your problem is not resolved after a reasonable period of time, notify the postal authorities.

Additional Thoughts On Buying A Camera

A "stripped-down" model may be the best buy for a starter; it means less expense, less to go wrong, and less confusion for the novice. Whether you choose a new or a used camera, remember that those with few automatic features would be a safer bet than those with many complicated controls, which may become defective. This is especially important in buying a used camera. Choose a basic, well constructed, well-known camera with a reputation for being dependable. If possible, shoot a roll of film through it, even if you have to do it in the store. This is a *must* if

it is a used camera. Before you put film in it, use the testing procedures in Chapter 4, "Getting To Know Your Camera." Listen to the shutter. How does it sound? Does anything rattle when you shake it? Examine the camera inside and out. Be sure that *everything* looks solid and feels solid. It should feel comfortable and "at home" in your hands, not foreign or awkward. Look for scratches or chips on the glass and dents in the metal. Big dents may indicate that the camera had been dropped, but small scratches are probably insignificant. Does everything seem to operate smoothly? You might examine the tiny screws in the camera's body for inept tampering. If they show evidence of being damaged by someone who has attempted to repair something, *beware!* Shop around and do much thinking before you decide. Buying a camera requires that an important decision be made, one that you must be happy with for a long time. If you have any misgivings about your ability to learn how to use a camera with complicated controls, choose a simpler one.

4
Getting to Know Your Camera

Whether your camera is old or new, simple or complex, and whether you take a lot of pictures or very few, you must be familiar with its operation. The best advice I can give anyone interested in any type of photography is know your camera!

Does your camera still have film in it from last Christmas? Is it almost that time of year again? If it does, and it is, then it is time to renew acquaintances. Before you use the remaining shots on the roll, take out the instruction book that came with your camera and read it thoroughly.

If it has been a long time since you made that last exposure, the film is probably stale. This is a good time to experiment in making close-ups just to see what your camera can do. Follow the directions in the instruction book. Select several sizes of photographs and heirlooms to photograph. Use flash, window light, whatever you need for additional light. Remember, this is an experiment so do not anticipate works of art. Use the film and get it processed. You are anxious to see what kind of results you will get from your close-ups.

Before you put another roll of film in your camera take the time to examine its interior. This would be a good point at which to give it a bit of cleaning (just a bit), and check the batteries. With a clean, soft, and dry artist's brush gently clean the sprockets and interior. Flecks of film, lint, and dust hiding there may eventually affect the operation of your camera or scratch your film. A rubber syringe (the kind used for babies or washing out ears) is useful for blowing away dust and film bits, but be sure that there is no trace of water in it. If it has been used for solutions containing chemicals, forget it. If you do not have a syringe, a camera

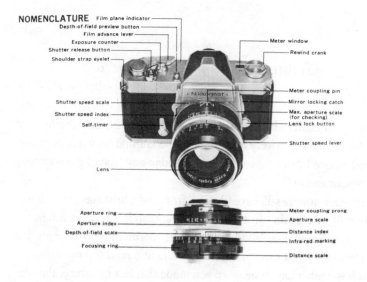

NOMENCLATURE Film plane indicator
 Depth-of-field preview button
 Film advance lever
 Exposure counter
 Shutter release button
 Shoulder strap eyelet

Meter window
Rewind crank

Shutter speed scale
Shutter speed index
Self-timer

Meter coupling pin
Mirror locking catch
Max. aperture scale (for checking)
Lens lock button

Shutter speed lever

Lens

Aperture ring
Aperture index
Depth-of-field scale
Focusing ring

Meter coupling prong
Aperture scale
Distance index
Infra-red marking
Distance scale

5 The anatomy of a camera: essential features. This is my Nikkormat FTN, a camera with TTL metering. Made in the 1960s, it has a shutter speed of 1-1/1000. Cameras of the 1980s will have features not found here.

shop can supply one that has a brush attached. Blowing your breath inside your camera might dislodge foreign particles, but the moisture could leave residue, especially on the lens. It is possible to buy a can of air (yes, air) with a nozzle to blow those bits away. Be careful with pressurized air on the shutter as it might damage it. Also, avoid touching the shutter with your fingers . Unless your fingers are scrupulously clean (and dry), do not touch the lens or the metal piece (the pressure plate) the film glides across. Fingerprints contain oil and may leave a dangerous residue. Wipe the pressure plate with a clean, soft cloth or dry chamois skin. To clean a lens or filter, use a lens-cleaning tissue (those for photographic use) that has been moistened with a drop or two of lens cleaner or distilled water. Form the tissue into a soft point and wipe gently from the center out. *Never* put the liquid directly on the lens as it could seep inside the

lens. A small chamois skin intended for photographic use works well. It has no lint and is washable. Cotton swabs are handy but fuzzy. Facial tissues leave lint also, but you can blow the lint away with the syringe.

If your camera's shutter will operate without film in the camera try the following, but first consult your instruction book to see whether it is advisable. With the camera back open, set the aperture to the widest opening and, with the shutter speed set as fast as it will go, observe the lens opening and listen carefully to the sound the shutter makes as it closes. Do this with each of the shutter speeds and lens openings. Listen to the difference in sound the shutter makes at different speeds. Notice the opening in the lens, especially when the shutter speed is very slow. See how the lens opens and closes as you change the f-stops. A camera's shutter is similar to a tightly wound spring-roller window shade. After it has been pulled down, it will quickly be pulled back by tension when it is released. An aperture setting can also be related to a window shade. When the shade is pulled halfway down it admits half the amount of light as when fully opened.

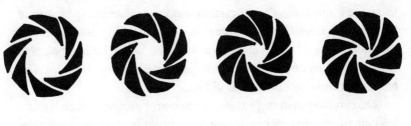

| f/4 | f/5.6 | f/8 | f/11 |

6 Openings provided by f-stops.

You should now have a better understanding of the camera's two most important functions. Do not put your film in yet, but close the camera back. If your camera's automatic features will not allow you to operate the shutter without film, don't go any further. Practice by pretending that you are taking pictures – not just one or two, but many of them. Find several different subjects and focus on them at different angles and dis-

tances. Practice tripping the shutter, keeping in mind that it must be done carefully and without moving the camera. Notice everything there is to notice. See how the exposure needle changes as you go from dark to light.

Become familiar with how your camera feels in your hands. Play with it. *Use it!* Use it enough that you will not forget how to use it in between times. Take notes. Get to know the feel and sound of the shutter at various shutter speeds. Learn how to hold the camera securely, how to take a steady stance, and how to use a "feather finger." Try holding your breath while making your exposures and push the shutter ever so gently.

Learning to control camera movement by training your body to be a tripod is one of the most useful and valuable tools I have ever learned. Once you get the hang of it, you do it instinctively. There may be times when it is not possible to include a large tripod in your photographic equipment, but a small one can easily be stowed away in your camera gear – if you are not burdened to the utmost with your genealogical research materials.

Get into the habit of putting the camera strap around your neck before you start shooting. At least, have it over one shoulder. You will feel more assured, so will your camera. Since my camera strap broke and let my Nikkormat FTN and 90mm lens fall clattering onto a cement sidewalk, I am like the old gentleman who wears both a belt and suspenders. I am now doubly cautious and I use two camera straps. The Nikkormat survived but the lens did not.

The two-strap system gives me more control over my camera and allows me to get into a picture taking position easily. It is also more comfortable. It lessens camera swing and the chance of the camera slipping off my shoulder. Experiment and find what is right for you and the type of photography you will be doing. Try placing both straps over your right shoulder and raising one of them over your head. Or you may prefer one strap over each shoulder. There are several styles of straps similar to my two-strap idea that you can purchase. Most have quick release snaps that allow you to get your camera into picture taking position almost instantly.

After you become comfortable with your camera all sorts of good things will begin to happen. You may find that your camera produces better pictures than you thought. When your pictures come from the film lab, study them. How were the close-ups? If you are satisfied, you do not need a new camera. If they were awful, you will need either more practice or a new camera.

Quite often it is the simple things we do (or don't do) that can ruin otherwise good pictures. The simpler the mistake, the more angry I become with myself. My biggest problem is determining whether or not my camera has film in it; and, if it has, is the film used or unused? My Nikkormat FTN's film counter has been broken for years (I never paid much attention to it anyway); and, occasionally, it allows me to take pictures when the film is not being transported through the camera. There are ways to check it, but I don't always do it when I am in a hurry. "Haste makes waste" is an old axiom that applies here. I just keep taking pictures until I feel a resistance as I flip the film advance lever. If I continue to push, I hear the film sprockets tearing. I can get carried away while taking pictures and have no idea how many exposures I have taken.

If I am careless or in a hurry while loading my camera, the end of the film slips right out of the winding reel. It helps to bend back about half an inch of the film's leader so that the film has a crimp when bent back. If I forget to do this or have not made sure it has started to wind, I can click merrily away, taking pictures that will never be developed, because the film is just sitting there, going nowhere. If the film is not used up in that shooting session, the next time I use the camera I have no idea of how many exposures are left. When I start getting suspicious that I may have a problem, I begin to investigate.

To determine if the film is in place, lift up the little lever on top of the rewind knob. Turn it slowly clockwise. If the film is not in position you can turn the little lever *forever*. If the winder is free as a bird, I know that there are three possibilities: either I have no film in the camera, I have a finished film in the camera that I have not removed yet, or I have a forgotten, unfinished film. Any of the three possibilities is bad news. If I find

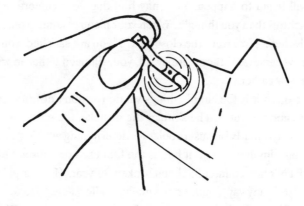

7 Turn the small lever on top of the rewind knob to check if there
is film in your camera or if your film is properly loaded.

a roll of film, I remove it and send it to be processed. Surprise! A roll of
unexposed film was processed, and the negatives are all blank.

One way to check that the film is transporting properly is to turn that
little rewind lever clockwise until you feel a resistance. Let the little lever
stick up when you make your next exposure, and watch it as you flip the
transport lever. It should turn as you advance your film.

This and other stupid camera mistakes can be costly. The fortunate
people reading this, who are by nature always thorough and organized,
shouldn't have any trouble. But, we unfortunate ones who are occasional-
ly prone to stupidity, must *beware*. This mistake is right up there on the
same level as forgetting to set the ASA/ISO dial when using a film of a
different speed. More about that in Chapter 5.

5
Film and Photographs

Black-and-white (B&W) photographs have withstood the test of time. In my opinion they will survive much longer than color. The snapshots and studio portraits of the black and white era have survived, despite the less than academic handling and storage to which most of them have been subjected. At one time or another, many of the old photographs you possess probably have been in hot attics or damp basements. They have been handled with moist fingers and pasted with all sorts of ruinous adhesives. How sad it is to think that precious photographs are being placed in the nasty magnetic, sticky-on-one-side album pages that promise to destroy them. Don't put them through any more torture! Learn how to protect and preserve them to prolong their lives. Many museums and historical and genealogical societies offer occasional workshops on archival preservation. They can supply you with information or tell you where to obtain it.

Black-and-White Versus Color

When I first started taking pictures, black-and-white film was all that was available. The first time I shot a roll of color film was after World War II. During the war, film was one of the many rationed or restricted (for civilian use) products. The first color film was worse than the quality of the first color TV program. The color prints were unnatural and faded fast. Perhaps the fault lay in the processing rather than in the film. Fading is a problem that reduces the usefulness of color film even today. Perhaps some of your recently taken photographs have faded already. Color prints may never be as stable as B&W, although the desire for color

photographs gradually led us out of the black-and-white era.

At first, B&W studio photographs were sepia-toned and were tinted by hand with oil paints. Those who could afford the luxury possessed photographs covered with heavy oil to resemble oil paintings and exhibited them proudly in a prominent place. With the advent of color film this practice began to wane. Today's amateur photographers seem to prefer color almost exclusively, though serious amateurs and professionals use both B&W and color, realizing that there is a place for both in creative expression. Black-and-white is probably unequaled for dramatic effect and for capturing exceptional detail. Ansel Adams's photographs are a good example. The black-and-white photos that for many years filled page after page of *Life* and *Look* magazines made such an impact upon our vision that some of them will never be forgotten. It's certain that B&W film is the choice for longevity.

Film

Film is one of several light-sensitive materials capable of producing an image. Paper, cloth, plastic, metal, china, and other materials can be dipped, sprayed, or painted with a light-sensitive substance called emulsion. Emulsion is a gelatinous substance that coats one side of a film's surface. The base of film is a plastic, such as mylar or estar. Most photosensitive items, such as film and enlarging paper, contain silver. The silver in color film and color reversal film is replaced by dyes during the processing procedures. Early films were on a nitro-celluloid base and were dangerously flammable. Old negatives that do not have "safety film" printed on the edge may be of that type. They have been known to self-destruct by spontaneous combustion. Consult a photo-archivist in your local or state museum, or someone knowledgeable about historic photos. It may be advisable that you destroy such negatives after making copy negatives or prints and enlargements.

Positive/Negative

When a sensitized surface is struck by light through a negative image,

a positive image results. Depending on the developing process used, a negative film can be developed either as a negative or as a positive. A positive film produces transparencies (slides) and can be either B&W or color. A type of B&W film called "direct positive" is used for B&W slides (transparencies) and for microfilm that has black lettering on a clear base. A negative microfilm has transparent (white) lettering on a black base. Books which contain photographs and illustrations are microfilmed on a positive film; otherwise the photographs would have a negative image.

Confusing? It really isn't after you understand the photographic process better. Most of the photographs we genealogists will be copying will be in black-and-white. Because B&W prints will last much longer than color prints, we will use B&W film to copy our photographs. We will use color negative film for subjects that are enhanced by color, such as colored illustrations, photos, landscapes, family homes and reunions, maps, and coats-of-arms. Color print film and a sepia-colored filter may be used to imitate a sepia-toned photograph for decorative purposes. You might try copying in a warm light if you do not have a sepia filter, as the prints tend to be of a warm tone without the aid of a filter. Color or B&W positive films can be used, if you would like to prepare slides for showing your family photographs on a screen at family gatherings or reunions, or for showing off your ancestors at your local genealogical society. While you are copying those old photographs, you might consider copying (in B&W) your favorite modern color photographs, especially those that are on display. Photographs should be displayed and enjoyed, but it is best to display only copies. Make B&W copies of any color photograph you cherish and wish to keep. Place the originals in safe storage away from heat, light, and moisture.

What's in a Name?

There are many types of film, each of which has a purpose. The word "chrome" in a color film's name usually signifies that the film is slide film, or color reversal film, while "color" in the name designates print film. Film is also typed for the kind of light it is designed for, such as "daylight" or

"artificial" (tungsten). Use each type in the proper light or use filters to correct the light. For more on this subject, see chapter 6.

Guide Numbers and Film Speed Indexes

Film comes in many speeds, and there is a purpose for each. How fast or slow you should go depends upon your immediate requirements. The film index number, or film speed, is marked on the box and usually on the roll or cartridge/cassette. It can also be a part of the film's name, such as Kodacolor 400. The larger the number, the faster the film.

A guide number (film index) is a rating of the film's sensitivity to light. A film that is extremely sensitive to light is a "fast" film. It has a higher index number. A low number indicates a "slow" film, which requires more light for exposure than does one of a faster speed. The index determines how much light is needed to expose the film properly. The lens opening and shutter speed can then be calculated automatically or manually, depending on your camera.

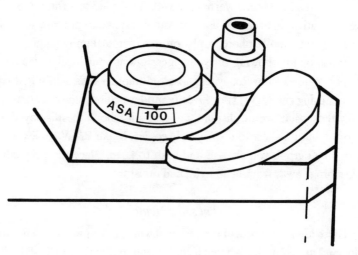

8 The ASA dial

9 *(Right)* On this particular box the ASA/ISO number is printed on the side. The figure 125 represents the ASA/ISO number. The 22° figure represents the DIN.

10 *(Below)* When in doubt, read your helpful instruction sheet.

KODAK PLUS-X PAN FILM FILM SPEED
IN 135 MAGAZINES 5062 ASA 125

Use this black-and-white film for general picture-taking. It offers the optimum combination of medium speed, extremely fine grain, and very high sharpness even at a high degree of enlargement.

Handling: Load and unload camera in subdued light. After last exposure and before opening camera, rewind film into its magazine.

DAYLIGHT PICTURES

Set your exposure meter or automatic camera at **ASA 125**. If negatives are consistently too light, increase exposure by using a lower film-speed number; if too dark, reduce exposure by using a higher number.

If you don't have an exposure meter or an automatic camera, use the exposures given in the following table.

DAYLIGHT EXPOSURE TABLE FOR *PLUS-X* PAN FILM				
For average subjects, use f-number below appropriate lighting condition.				
Shutter Speed 1/250 Second		Shutter Speed 1/125 Second		
Bright or Hazy Sun on Light Sand or Snow	Bright or Hazy Sun (Distinct Shadows)	Cloudy Bright (No Shadows)	Heavy Overcast	Open Shade†
f/16	f/11*	f/8	f/5.6	f/5.6

*f/8 at 1/125 second for backlighted close-up subjects.
†Subject shaded from the sun but lighted by a large area of sky.

For handy reference, slip this table into your camera case.

You need these guide numbers to set the ASA/ISO dial on your camera and strobe (flash), otherwise your film will not be properly exposed. Some of the newer cameras are able to read the guide numbers directly from the film by an encoding system, and the adjustment is done for you. The guide numbers of film are preceded by initials such as ASA or ISO and DIN. DIN is the European equivalent of ISO and ASA, and is found after the slash following the ASA or ISO number on the film box. Unless you are purchasing film abroad, or have a European camera, you will not need to use the DIN rating. The only guide number you need to be concerned about is ASA or ISO. ASA is "American Standard;" ISO is "International Standard." ASA is the older term, and has largely been replaced by ISO. Incidentally, the ASA and ISO numbers are the same. Changing these settings when changing to a different speed film is one of the little things you occasionally forget.

An entire roll of overexposed or underexposed pictures is something to cry about. Unless your camera is one of the newer, state-of-the-art cameras, which are able to read the guide number directly from the film, you *must remember* to set your camera's guide number each time you change to a film with a different speed. After you have experimented with various films and have found your favorite, or favorites, there will be less need to worry about this problem. If your camera does not have a slot on its body to hold the end of a film box, be sure to buy one of the stick-on kind. They are inexpensive and are an excellent reminder of the kind of film currently in your camera. As long as you have not forgotten to insert the box end, you can check the film speed when in doubt. These guide numbers may also be needed to calculate flash.

If you forget to change the ASA/ISO setting on your camera when you use a film of a different speed, all is not lost. When you send the film to be processed, notify the lab of your error. Tell them the index number at which the film was exposed, and have the film developed by "pushing" or "pulling." Push or pull processing can save your film, but sometimes to the loss of detail or negative quality. Photographers often change the settings intentionally. Some cameras have a plus/minus setting to use when bracketing exposures rather than for the changing of the aperture

setting. Some of the newer cameras will automatically bracket your exposures if you wish. A slightly altered ASA/ISO is sometimes preferred when using certain films for a special effect. When shooting negative film, overexposure is less dangerous than underexposure; when shooting positive film, underexposure is not as harmful as overexposure. Some authorities advocate consistently slightly overexposing negative film and slightly underexposing positive film to give better detail and more depth to the shadow areas. This is called "shooting for the shadows." Because of the performance differences in cameras, lenses, and film, we should know what to expect of them. Every photographer should know the limits of his camera and of the film he uses. Don't experiment when taking important pictures! Try out new equipment and unfamiliar film before it becomes necessary to use either. Have the right film available for the right job, and you should have no problems; but, if you do not, take an ample number of exposures. Remember that film is the least expensive item in your photo equipment and that you are taking important pictures.

The Right Film for the Right Job

Quite often it is necessary to use the film that is in the camera whether you wish to or not. When you have no other choice and must use a film having the wrong speed, you will have to decide whether the pictures already on your film are more important than the pictures you are about to take. If pictures yet to be taken will be the more important, change the film speed setting and have your film processed by the push or pull method. If the speed is only slightly altered, you may get by without having to make a decision. Negative film will not suffer as much as positive film because it has more latitude, or wider range of exposure.

If you do not wish to use the film in your camera, you can remove it and replace it with the film you prefer. Take note of how many exposures have already been made and rewind the film back into the cartridge. Listen as you wind, and when you hear a click or a different sound *stop winding!* Should you have wound the leader into the cartridge, do not despair. A good camera dealer should know how to retrieve it, and there are tools for sale that will do the trick. When you wish to use the rest of a partial-

ly exposed roll of film, load it as before, and with lens cap covering the lens, shoot off the necessary exposures. Allow one or two for good measure, or you may have double exposures. If you are uncertain whether the film has been rewound exactly as before, ask the film processor to return your negatives uncut, or you may find the remainder of your negatives cut in the area of the photograph.

Fast Film for Low Light

To take photographs by candlelight or moonlight you will need a film with plenty of speed. If you do not want a whole roll of romantically lit pictures, you could rewind the film back into the cassette and save the remainder until you are in the mood to take more candlelight or moonlight pictures. A film that is fast enough for low light exposures would be hopeless for use outdoors in bright sunlight – you could never "stop-down" your aperture sufficiently. You might use a neutral density filter to cut down the amount of light passing through the lens, or a polarizing filter would help also. Fast films (such as Tri X, ASA/ISO 400) are good for available light shots of interiors, such as the dark interior of an old barn, and faster shutter speeds for shots of fast moving subjects, such as cars, horses, and athletes. Nature photographers also need fast shutter speeds for action and for minimizing shutter movement when using telephoto lenses. Also, long lenses need more light. You might remember this by thinking fast action needs fast film, a fast shutter speed, or both.

Medium Speed or General Use Films

A medium speed film should be capable of handling almost any type of daylight exposure. The speed is sufficient in low light situations when the camera is on a tripod or other firm support. Medium speed negative film makes good enlargements because of its fine grain. The same is true of medium speed transparency film.

Slow Film

Some photographers like slow film for outdoor photography in bright sunlight because of its wide tonal range. Slow film has ultra-fine grain for excellent detail and resolution. It is preferred when a photograph must be greatly enlarged or severely cropped. Such a fine-grain film is Panatomic X, ASA/ISO 32, and it is best used when the camera is on a tripod or copy stand because it is often used with a slow shutter speed. It can also be used for copying photographs outdoors by available light, if there is enough light or your camera is on a camera support. Plus X, ASA 150, is another fine-grain film for copying photographs. It yields a little more contrast than Panatomic X and can eliminate the over all gray look (depending on the photo developer) that sometimes occurs in rephotography.

General Purpose B&W Film

Ordinary B&W film for general purpose use is panchromatic, meaning that it is capable of recording color in the various tones of gray which appear natural to the eye. Most B&W general purpose film is panchromatic. Films for special use have different names for different characteristics. "Pan" within the film's name indicates that the film is panchromatic.

Orthochromatic/Ortho Film

Orthochromatic film is more sensitive to some colors than others. Films that have "Ortho" within the name, such as Kodalith Ortho, give high contrast by leaving out (not reproducing) some of the middle tones. This is desirable when copying stained and faded documents. It is also useful for certain specialized types of photography because it will not reproduce all colors naturally, and it can make photographs appear to be line drawings. If your prints of faded photographs and documents are unsatisfactory, you might try an ortho film.

Infrared Film

This film can record things which the eye cannot see. Infrared film is sensitive to invisible radiation; therefore, it can detect energy or heat. It is useful to law officers in that it can detect counterfeit money and erasures on checks and documents. It can aid genealogists by allowing them to read the writing obliterated from a faded document or a worn tombstone inscription. Old letters and aged documents that have faded almost beyond recognition can be brought back to life via a photograph on infrared film.

This film is difficult to use as it calls for special filters and special subject-to-film measurements. It requires trial exposures and a lot of patience. Your camera manual should have special instructions. Infrared film needs special handling and processing, so it is not a film to use casually. Consult a professional for advice.

Why Grain?

Grain is the structure of film, somewhat like the cells of our skin. Under a magnifying glass our pores look like minute holes. Some skin does not need magnification to see "pitty" pores. The same is true with film. A film's emulsion is made up of tiny clumps of gelatinous matter. The size of a clump (grain) varies in different films. The faster the speed of the film, the larger the clumps of substance. Grain is not too noticeable unless a negative has to be greatly enlarged. Users of disk and other miniature cameras may notice that their pictures have a mottled look. This is caused by grain, and it is the price you must pay for the convenience of a small camera. It is caused by the extreme enlargement of those tiny negatives.

Another thing that influences the grain of film is the way in which it is processed. The chemicals used in processing, the temperature of the solutions, and the time and type of development will all have an effect on the contrast and the grain. There are times when a photographer purposely makes changes in processing to achieve a special grainy effect. Ordinary "Pan" (panchromatic) film can be processed in special develop-

ing solutions that will give the photographs more contrast and take away the overall gray look that sometimes occurs when photographs are copied, especially those made from faded and low-contrast originals. Any change in the accepted mode of film development will have an effect on contrast and grain. If you wish to avoid grainy photographs, a good rule to follow is not to use a film that is too fast for your purposes. Reserve the ultra fast film for those special times when it is needed, such as taking pictures by candlelight, moonlight, or other low light situations.

Mail-Order Film

You can save money by ordering film in bulk from mail-order houses, which advertise at the back of photography magazines, such as *Popular Photography* and *Modern Photography*. They also offer 35mm film cassettes and film "spoolers" so that you can roll your own film. Be sure you get what you order and that it is fresh. Rolling your own film can be done without a darkroom with daylight loading equipment. If you do not care to do this yourself, film can be ordered in quantity, "factory fresh," in rolls or cassettes. Another 35mm film available by mail order is made by Kodak as a motion picture film. Only a few labs are equipped to develop this film, and their advertisements can be found in photography magazines or newspapers. The film is called "5247" and "5294," and the name of the film processor may appear as part of the film's name. I have used 5247, but not 5294, as it offers the advantage of both prints and slides from the same film. You may order slides only, prints only, or both, and yet receive the color negatives.

Film should be processed as soon as possible after exposure because the film's emulsion changes more rapidly after it has been exposed than before. See the advice on film storage in chapter 13, "Traveling with Your Camera."

Film Processing

Finding a good B&W film processor may be very difficult. There are

11 An example of a photograph struck by light, either through carelessness on the part of the photographer when loading or unloading the film, or by the processor. The round, dark spots were caused by air bubbles during processing.

12 The above was caused by the processor printing the negative reversed. The same company was responsible for the problems in figure 11.

13 The dark scratches that run vertically over this print were caused by the film being scratched either during winding in the camera or by the processor.

not too many choices available. There are custom labs that will do your processing to your specifications, but they are more expensive and somewhat elusive. There are many advertisements in photo magazines for color processors, but seldom do you see one that offers processing for B&W, much less a specialization in custom B&W developing and print-

ing. Kodak labs have again offered B&W processing, and I find that their prints have more snap than those I have had processed locally. What used to be called "drug store prints" are available at nearly every drug, grocery, and discount store; however, their one day services apply only to color work. Black-and-white is usually sent to a nearby lab, and the processing usually takes a week or so. Generally speaking, such service is not too reliable for quality. A custom lab will offer handmade prints and quality enlargements.

Inquire around and seek a B&W processor with a good reputation. Ask a professional photographer where he sends his work. Many professionals do their own, but some people would just as soon trust the developing to others (*if* they are able to find a processor who can satisfy them). Do not send a big batch to one processor at one time, especially if it is the first time you have made use of their services. It might be a good idea to send your practice rolls as samples to several processors. These could be your first attempts at copying, and something that you will have a chance to do over if necessary. Be sure to bracket exposures and try several procedures. Send a roll of film to each of the processors you are considering, and carefully examine the negatives and prints when they are returned. It is difficult to avoid a bit of lint and dust spots in processing, but if these faults are excessive, I would avoid the processor concerned. When the results are unsatisfactory, ask why. Stick to the lab that gives consistent satisfaction. A good negative should have good, but not excessive, contrast. Contrast and other factors may be the fault of the photographer, so do not blame the processor for something your vigilance might have avoided. If it is your fault, you will have to adjust your exposures accordingly. You might look at the classified advertisements in metropolitan newspapers or study the magazines mentioned earlier for B&W processors.

The Border Dispute

It depends on how your negatives will be printed just how much of a margin you will need to allow around the photograph you are copying. If

your processor will print only borderless prints, you may have boundary problems. I have found that the processors who provide only borderless prints use automatic equipment that eliminates more of the negative than it should in the printing process. If possible, discuss this with whoever is responsible for accepting your film for processing *before* you do any rephotographing to see how much margin to allow.

The processor I had been using always gave me prints with borders. Generally speaking, I was able to include what I wanted in my copied print. I tried not to include portions of the album surrounding the photograph if I didn't have to. I worked hard to include all of the picture area that I wanted in my copies and to eliminate all that I did not want. I learned to allow for the portion of the picture's area that would be eliminated by the photo finisher's equipment, until the photo shop changed B&W processors and I could no longer get border prints that contained the amount of picture area I had grown to expect. When my prints came back they were borderless and were accompanied by a note which read, *"Don't Crop So Close, Automatic Machinery ... etc."* Not only were my prints borderless, they were topless, sideless, footless, and almost headless. The automated printer used so much of the negative area to position the negative for printing that they were barely recognizable. The chopper particulary loved one side of a roll of 35mm film, and any such thing as a symmetrical balance was out of the question. As with many things these days, automation could care less about the results. I was appalled. I would not be antagonistic towards borderless prints if they would only take off an equal amount from all sides. If you have to settle for lopsided, borderless prints, you will need to leave ample margins around the picture to be copied, as you will not know how much or which sides of your print the automatic equipment will eliminate. Compare your prints with the negatives to see how much of the negative has not been printed. I am not thrilled about having unsightly, uneven, and unwanted borders (of whatever surrounds the photograph I am copying) just to satisfy machinery that parallels the attitude "one size fits all." If your luck with processors has been like mine, you may decide you would like to attempt the developing and printing procedures yourself. To learn more

about film, developers, and the like, good sources of information are the many excellent books, booklets, and pamphlets put out by Kodak and other camera firms. If you cannot find what you need at the photo shop, ask the dealer, and he can help you order what you need from the Kodak Company. Again, I suggest the library for books and magazines which address special photographic needs.

Storing Your Photographs and Negatives

Store your negatives in mylar or polyethylene sleeves, or sheets, intended for negative storage. Be sure that the plastic is either mylar or polyethylene, as some of the older sheets contain material that would be harmful to your negatives. Anything that becomes brittle with age is not to be used. Do not put more than one strip in a sleeve. The sheets are punched to fit a three-ring binder, and any identifying names, numbers, or other information can be written on the sheets with a permanent ink pen. Never write on the sheet that contains the negative, especially with a ballpoint pen. Any additional information, such as exposure data or information about the photographs, could be written on three-ring paper and placed with the negative sheets for reference. A contact print, called a proof sheet, made from the entire sheet of negatives would aid in the identification of the pictures and assist you in determining which pictures should be produced as prints or enlargements. A good magnifying glass helps to scrutinize small details.

Store the notebooks containing the negatives on metal shelving, allowing space for air circulation behind them and on top. Avoid wood or pasteboard boxes to store negatives, prints, and photographs. Use instead baked-on enamel metal boxes or file cabinets. Special metal file cabinets for negative and slide storage can be purchased. Do not use air tight or sealed containers, as paper and film must breathe. Store all photographic materials away from fumes (gas, coal, or wood furnaces; solvents, paints, and chemicals); even mothballs and spray cans can be life threatening to those precious images. Avoid storage in areas of extreme or fluctuating temperatures and humidity. Use packets of silica gel to absorb any excess moisture. If the silica becomes moist, dry it accord-

ing to instructions on the package. Kitty litter, especially the kind made of clay, is a good substitute for silica gel. It will absorb moisture and odors. Make packets of kitty litter and soda (about two-thirds litter and one-third soda) and wrap in sturdy paper or closely woven cloth. Place the packets with your old photographs and documents. Check occasionally for dampness and replace if necessary. Should you find dampness consider a safer storage area. Such materials help absorb the unwanted odors and may prevent further deterioration from these paper foes.

Do not *cut* negatives! Send the entire strip when ordering reprints. Avoid pasting prints in albums. If you must paste, do so only by the corners. Try cutting diagonal slits on the page to insert the photo's corners or use adhesive photo corners. Forget spray-on adhesives and rubber cement. Both are bad for photographs, paper, and lungs. Ban also those magnetic, peel-apart albums I spoke of earlier. The adhesive contains acid, the plastic probably contains chlorine or other harmful agents, and the photographs will not be able to breathe. Once your pictures are inside these magnetic pages you may not be able to pry them out without injury to the photographs. Polyethylene bags, such as Glad Wrap sandwich bags, can be used to store photographs. Only polyethylene and mylar are safe plastics for photographic and document storage. Never use polychloride or acetate. Again, I would advise you to learn more about archival storage for your family treasures.

6
Filters and Other Funny Things

There are many kinds of filters. They come in different shapes and sizes, and uses for them can range from necessary to frivolous. If you have filters, they are seldom where you want them when you want them; and whenever you have them with you, you seldom need them. For photography in general they are used rarely as they might diminish image quality, especially when used in combination. However, there are times of crisis in which the proper filter would come to the rescue – if only you had it with you.

Filters can be square or round depending on the type of filter and its filter holder. The best filters are made of optical glass, and they will have a minimal effect on the optical system of your lens. Glass filters either screw into a lens or fit into a "series type" retaining ring that screws into the lens. Screw-in, optical glass filters are the most convenient, the least apt to cause optical problems, and the most expensive. The least expensive filters are the gel (gelatin) filters. They come in sheets of various colors and fit into different types of filter holders. They are used for creating special effects but can be used in correcting a light source in close-up and copy work. They scratch and fingerprint easily, so they must be cared for properly. If one is dropped on the floor, you may step on it several times before finding it. They are so thin they can disguise themselves as nothing quite successfully.

If you have several lenses for your camera, you may wish to purchase a series type filter rather than the screw-in variety. The screw-mount filters are sized by millimeters and the series type filters are purchased by numbers such as 5,6,7, and 8. The series filters fit into screw-in retaining

rings that are sized by millimeters. In buying a separate retaining ring for each different size of lens and a series filter to fit the largest retaining ring, the same filter can be used for all lenses. These retaining rings are known as step-up and step-down rings. The reason for selecting the filter to fit the largest ring is that a filter smaller than the lens would cause vignetting. The result would be circular shaped photographs.

Vignetting will also occur when you use too many filters in combination or a combination of close-up lenses and filters. Close-up lenses come in different strengths, such as plus 1 and plus 2; also, as 1x and 2x. If more magnification is required, they may be used in combination. If used together, place the strongest closest to the lens. The more surfaces between the subject and the lens, the more the image is affected.

Color Correcting Filters

Color correcting filters (also known as conversion, or color balancing, filters) are used in color photography to correct the light source being used. The light source must be the same color temperature as the type of film in use. Natural light can be warm or cool, according to the time of day. Light reflecting off snow and water is cool, unless it also reflects the warmth of an early morning or late afternoon sky. Around sunrise or sunset, the normally cool sky is warmed with red and orange. Pictures taken during that time will have a reddish cast. There are blue-colored filters to cool the early morning or late afternoon sky if the light is not suitable for the subject being photographed. Generally, the way nature has created the scene is the way a scenic landscape should be photographed. A person photographed under such lighting may not appear natural, and a filter would be needed.

Artificial light (tungsten or fluorescent) has a tendency to be cool, and pictures taken under such lighting may be bluish or greenish. Color conversion or color correcting filters will correct these conditions if the film being used is not compatible. Filters are employed less today for color conversion than they were years ago, since camera flash and film are now more closely balanced. When available light is the main source

of lighting it should balance the type of film being used, or the photograph will be either warm or cool in color. Refer to the film sheet in your film carton for the proper filter in such situations.

There are special filters to correct the light of fluorescent fixtures. Unless filters are used, pictures on the same film will not render color accurately when taken under different kinds of light. A filtered light source is used in the processing of film. As prints are made, they are automatically filtered by machines. The lab equipment will analyze the negative for color and filter the prints accordingly. When several types of light source are on the same roll of film, the automatic equipment cannot filter all the prints properly. This is why reprints may have different overall color than the original prints. An occasional off-color photograph, produced by the wrong lighting or improper filtering, can be corrected during the processing of a reprint by a photo processor. Some labs will reprocess those of their own prints that are unsatisfactory because of objectional overall color.

Special Use Filters

Filters cut down the obliterating effect of atmospheric haze. They are useful for minimizing the haze that affects mountain, seashore, and city scenes. Sun reflects upon droplets of moisture in the atmosphere to create haze. The use of a UV (ultra-violet) or haze filter will help to reduce the reflections and cut through the haze. A polarizing filter can reduce or eliminate glare, haze, and reflections, especially if the light source is polarized as well. A polarizing filter can reduce the amount of light that passes through the lens so that as much as ten times the amount of light is needed to make an exposure. The filter is capable of many effects, depending upon the angle at which the light is striking the subject. The filter is rotated until the correct angle is reached and the glare or reflection disappears, or is minimized, as you see it in your viewfinder. A polarizing filter is useful when photographing a picture with a glossy, reflective, or textured surface. It also helps when making a photograph of a picture under glass.

A neutral density filter should be used when you have fast film in your

camera and you must take pictures in bright light. Sometimes it is not possible to adjust your shutter speed and aperture combination in order to keep from overexposing the film. A neutral density filter cuts out the light reaching the film, thus saving the day for picture taking. Neutral density and polarizing filters can be used with B&W film as well as color.

There are many exotic filters, such as those which make several images of a subject on the same negative, or which give an unnatural appearance to the photograph. Unless you really get hooked on creative photography, you will not need these.

Filters for Black-and-White Photography

A colored filter is used in B&W photography to mask a color or intensify it. Filters are helpful when copying old photographs to help intensify an image. As B&W photographs fade they tend to become yellow. A filter the same color as an image will lighten the color (and the image), and a filter of the opposite color on the color wheel will emphasize the subject's color. A photograph that has yellowed and faded to a pale image can be improved by being photographed through a blue filter. The paler the image, the darker the filter must be. Blue is the opposite of yellow on the color wheel.

I have used several blue filters of different densities, or intensities, in my copying. The darkest (80-A Access) appears so dark and dense that it would be impossible to take a picture through it, but it works. I also use

14 *(Left)* Compare the small oval photographs on these album pages. The dark images are tintypes and the other small ovals are cabinet photographs. The tintypes were overexposed by the amount of light needed to expose the album sheet containing both photographs. The camera's metering system estimates the amount of light needed to photograph the album page. When there are extrmes of light and dark within a photograph, one portion will be either under or overexposed. It will be difficult to strike a happy medium. It is necessary when copying individual photographs to meter and expose each photograph separately with and without a gray card. The larger photographs are copies of the tintypes made with an 80A (dark blue) filter on the lens. After carefully metering the individual photographs, make an exposure with and without the filter. To be on the safe side make additional exposures of another full or half-stop on each side of those readings. If you wish, you could go as far as two full stops.

an 82-A Spiralite (light blue), and at times have used light blue gelatin sheets. I copied several tintypes with the 80-A Access filter as an experiment, and somehow the resulting image was remarkably improved. The highlights that were a gray-yellow and barely visible in the original, became brighter and lighter. There was detail not evident in the original tintype.

If, on the other hand, you have a B&W photograph marred by yellow stains, use a yellow filter such as a G-15 to mask the yellow stain. The resulting copy of that photograph will be improved. It is possible that the stain will not show at all. A filter of the opposite color (blue) would darken the stain. Filter designations differ from one brand to another. A

15 Color wheel showing hues placed opposite their contrasting colors.

filter made by one company may look identical to one made by another, yet the filter numbers may be different. A filter with the same number as one from another company may also be different. Consult the filter brochure of each company and study the various uses for filters.

Filter Factors

Filters alter the amount of light passing through the lens. To make allowances for the amount of light lost, the lens opening (aperture) must be increased or the shutter speed decreased. This is determined by a filter's "factor." The factor is simply another guide number. Filters that are more dense than others will shut out more light than will filters with less density. The filters with more density will have a larger number filter factor. If a filter has a factor of 4, the lens would need to be opened two f-stops. The beauty of a through-the-lens (TTL) metering system is that you do not have to make these mental calculations and manual adjustments. The work is done for you.

There are times when it is necessary to double-check TTL metering. When using a very dark filter, the TTL metering might become less accurate. Take a reading without the filter and subtract the filter factor to compute your lens opening. With certain TTL meters there might be differences. My camera's TTL system is not affected too adversely. I am usually able to rely on the reading made by my camera. I also use the reading it gives from a gray card. If there is a variance between the two readings, make exposures using each. It is always a good idea to bracket exposures when difficult lighting situations are encountered.

It is also possible to filter the light source. If not done properly this could create a fire hazard, especially for the filter. Usually, color correcting or polarizing filters must be mounted at a distance from the bulb to allow for sufficient air circulation. Such filters are usually color correcting, or polarizing. Care must be taken to insure that the bulbs are the proper size and that the socket is heat-resistant. Your eye is a good judge of what a filter can do. Since there are similarities between the eye and a camera lens, looking through a filter will give an impression of the effect made by a filter. Photographers who shoot B&W photographs can obtain a filter that is held to the eye for viewing a scene to see how it would look in a black-and-white photograph. You may have some transparent, colored sheet protectors, or any material that is transparent

and also colored. Look through them at a variety of subjects and study the effects. Notice the effect of a color upon different objects. Look through red at something written in red. Look at the same red writing with the opposite color (blue-green, blue or green). See what I mean!

Filters of various hues made for B&W photography can change the way B&W film "sees" a subject in a photograph. In scenic photography a yellow filter will darken the sky and clouds will be whiter by contrast. An orange filter will darken the sky even more. A green filter makes green foliage appear lighter. Such filters are used to dramatize an effect or to emphasize a subject against a background that might otherwise have made the image appear nondescript.

16 There are several types of cable shutter-releases. You may prefer one type to another. I like the kind that is activated by a blast of air (pneumatic). It has a bulb that you squeeze. The newest type of cable release is activated by an electronic impulse but can be used only on cameras for which it was designed. It is very important that you use a cable release when using slow shutter speeds; for example, when your camera is on a support. It is helpful in taking close-ups and almost essential in copying photographs. There is a certain amount of vibration within the camera when the shutter is released; and when this is compounded by the human hand pressing the shutter button, it affects the quality of your picture.

Such knowledge of filters and what they do would be helpful should you come across a problem that you may not know how to handle. Filter manufacturers often have giveaway brochures that explain the uses for their various filters. Look in your local camera shop, or you might see an advertisement in the photography magazines. When you have problems, take them to the man behind the counter at your local photo supply studio. Explain your requirements and purpose, and hope that he is knowledgeable about the subject.

Lens Hoods

The curved surface of a lens is affected by stray light and reflections. The quality of your photographic image will be reduced because of it. The larger the lens surface the greater the problem, especially at certain lens openings. Sometimes the lens flare, as it is called, is in the form of circles or geometric shapes, such as those from light shining through a prism. Some lenses are designed with the glass surface recessed deep into the lens; other lenses have built-in, adjustable lens hoods. Should you notice unwanted shapes, usually light in color, appearing in your photographs, you may need a lens hood.

Gray Cards

A gray card, made for photographic use, is simply that: a gray card. It is the tone of gray that approximates the middle tone of a photograph. A reading through your camera's exposure meter from a gray card should give you the best range of highlight and shadow. A gray card is especially helpful when photographing photographs. I usually take one exposure using the meter reading my camera's system gives me and another from a gray card. Gray cards can be used with color film, too. They can be purchased at photo supply stores.

7
Tripods, Copystands, and Beanbags

The old saying, "You can always tell a professional photographer by his tripod," isn't always so. It is not a status symbol nor is it used to attract attention. I am not a professional photographer, and I certainly don't want to attract attention. In fact, I feel downright stupid carrying a tripod; consequently, I seldom use one (a large one that is). Perhaps it is because of my grandmotherly age that I feel foolish toting a tripod. Perhaps it is because I am a woman. Women seem to have enough of a problem hanging onto their purses. When women are genealogists as well as grandmothers, carrying a purse and tote bags full of notebooks, plus a camera, they have their hands full without attempting to juggle a tripod. If you do not mind attracting attention, being classified as a pro, or being associated with a status symbol by some, go right ahead and use a tripod! You will produce *much* better pictures.

A tripod, copy stand, or other support, holds a camera securely while an exposure is made. The vibration caused by the camera's shutter being tripped can be detected in pictures, especially those made at slow speeds. Some kind of support should be used to insure that your camera achieves the best likeness possible. Using a cable shutter release also helps eliminate camera shake. A cable release should be used at all times when a camera is on any form of camera support.

Whenever my mode of travel (or my abilities) will not allow me to carry a large tripod, I rely on something else to steady my camera, such as a small tripod, cars, window ledges, and tombstones. I lean against trees, walls, doorways, sides of buildings – whatever is available. It is necessary when you use slow shutter speeds. I have even taken time ex-

posures that way. Though the results are imperfect, they are interesting; and this has produced pictures I would not have been able to photograph any other way. Small objects can be used to position your camera for shooting. Cradle your camera's body to prevent vibration when the shutter is released if your camera is resting on a smooth, flat surface during exposure. A towel, pillow, sweater, or other soft item will act as a shock absorber.

A beanbag is a useful tool, and so simple to sew anyone could make one. A square or rectangle of sturdy fabric, such as denim or old slacks, can be filled with dried beans, rice, or corn. You might take a couple of empty bags on your travels for an emergency prop and fill them with what is available. Beanbags also help steady tripod legs sitting on hard or uneven surfaces. A beanbag leaning against your copy stand or enlarger post will give added protection from vibration while you are copying or enlarging.

Whenever I stay in hotels, I almost always take pictures from the windows. I am especially fascinated with night scenes, their glittering array of colorful, dazzling lights. I place my camera upon a small tripod, or prop it on a window ledge, and use an extremely slow shutter speed or time exposure. If the window can be opened, the unwanted reflections can be eliminated. This can be a risky venture so keep your camera secure and place the strap around your neck.

I am both fascinated with and frightened by heights. I feel dizzy and light headed, as if some force were going to push me down an open staircase or over a balcony or window ledge. But, when I have a camera in my hand, the intense desire to take pictures from extraordinary heights wins out, regardless of my fear. It is the same way with storms. I am terrified of severe storms, but where do you think I am during a tornado warning? Outdoors trying to get pictures. That is, after the wind passes that threatened to carry me away.

17 *(Right)* From our hotel room overlooking Temple Square, Salt Lake City. Notice the difference in the time of day and the way in which light changes the appearance of shapes. Whenever possible use the time of day to your advantage in taking pictures.

Whether you need to invest in a copy stand depends on the amount of pictures you will be copying. Training your body to be a copy stand is much more difficult than training it to be a tripod. You must lean over at precise angles and be as motionless as possible. You might decide to invest in a copy stand after trying one. If you can hand hold your camera steadily while leaning over your subject in a backbreaking position and keep the camera and subject on the same level, fine! You will need to learn the technique, as you may not always have a camera support available. A tripod with a removable head can substitute as a copy stand. The tripod head is turned upside down and replaced on the tripod shaft. The camera can then be mounted in an upside-down position with its lens towards the floor or table top. The subject to be copied is placed under the camera and the tripod's legs adjusted to the proper height.

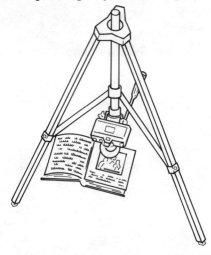

18 Using the tripod as a copy stand.

There are several kinds of copy stands available, each has its virtues. The copy stand that I use for most of my copying has a heavy wooden base and must have been designed for men and amazons. When I release the tension knobs to adjust the arm, the heavy-duty spring flings the arm

in the air. It is not yet ideally suited to me, as in order to copy large photos or documents I must stand on a stool. An adjustable copy stand base or a removable pentaprism on my camera would be the answer to this problem; however, a removable pentaprism was not built into my Nikkormat FTN.

I also have an inexpensive copy stand that can be taken apart for travel. Instead of a wooden base the lightweight stand has "V" shaped legs that tip over easily. It can be set upon an album page so that photographs on the page may be copied without being removed; therefore, the two-legged stand, aside from being portable, has its specialty. Your working space beneath a camera on a copy stand is extremely limited when copying. There is little room to maneuver scrapbook or album pages from which you wish to photograph only a portion containing an illustration. You will learn more about this through experience.

One thing that is very handy on any type of copy stand is a focusing rail. A focusing rail is a gadget that has gears (a sort of rack and pinion), which allows you to focus one millimeter at a time. It is a real time and work saver. Most of the time one millimeter is all it takes. The focusing rail is attached to the copy stand, and the camera is attached to the focusing rail. Photographs vary in thickness, just enough to throw your lens slightly off focus. It is easier to focus that minuscule amount with the focusing rail than by moving the lens or adjusting the copy stand. A focusing rail can be purchased by mail order from Spiratone (and others), who advertise in photography magazines.

Someone with a bit of ingenuity and handy with tools could make a copy stand. Plans for homemade copy stands have appeared in photography books and magazines, and these can be consulted in your local library. You can also make camera supports that will allow you to fasten your camera to such things as table legs, chair backs, and car windows, using items from the hardware store. Grips, vises, and clamps can be attached to a tripod head – but they *must* be trustworthy. Persons with undeveloped mechanical abilities should buy rather than attempt making their own. With any such homemade devices, be sure that you carefully measure the length and width of the bolt on which you will mount your

camera. Common bolts can be used, but be especially careful of the depth that the bolt is inserted into the camera base. Anything you fasten to your camera *must* have the proper size connector. *Never* force anything! Consult a mechanic or person knowledgeable in metal and welding for advice and know-how.

I prefer copying with the subject in a horizontal rather than a vertical copy setup. I once tried copying with the subject in a vertical position, but quickly abandoned the project. My camera was on an upright tripod, and the photograph I was attempting to copy was fastened to the refrigerator by magnets. I spent several hours wrestling with the tripod, loosening and tightening the knurled tripod knobs, until I had blisters. Attempting to get the camera at the right height and level was almost impossible. I moved the photo (and magnets) many times, and would return to my camera to find the photo still crooked in the viewer. I said to myself, "There has to be an easier way!" There is an easier way: place the subject flat on a horizontal base so that gravity can work as your assistant. There is no simple way to mount pictures in order to copy them vertically, especially with a tripod. A person could get motion sickness adjusting the tripod up and down, in and out, back and forth, or sideways.

The camera's film plane (position) and the photograph must be on the same horizontal (or vertical) plane or areas of the photograph will be out of focus. A small, inexpensive level will help. The kinds used to level pictures and appliances work well. The circular one with both vertical and horizontal bubbles is best. The level is placed on the table or copy stand base, then on the camera. If one is a bit off, shimming the base with pieces of cardboard is easiest.

If the subject you are copying is in a book, the page must be level with, or on the same level as, the camera's film plane. A book can be propped to make the page you are copying as level as possible. This is difficult when a subject persists in staying where you do not want it. I use all sorts of things: long rubber bands, weights, and clamps. Use your ingenuity, and you can devise your own photographic helpers.

Some method of holding the photograph flat and immoveable (once you get it where you want it) is essential. The heat from the copy lights

a The entire photograph the original of which I borrowed in order to make a copy. The subject is the men of the Burlington shops, Havelock, Nebraska.

b The camera is moved closer to include a portion of the photograph (the left center).

c Moving yet closer I selected this area because it includes my father (the third man from the left). A difficult picture to crop as the many heads and feet made an awkward composition, no matter how it was observed through the viewer.

can cause a photograph to buckle or curl, even though it may be mounted. Photographs can be harmed by heat and light. Do not leave them under the lights any longer than necessary and check them frequently for overheating. Magnets and a metal base are useful for holding photographs securely. I use long, thin, flexible, magnetic strips that are an inch or so wide. They are placed on the borders, or corners, of the photographs, with care being taken not to obscure any more of the picture than is necessary. Magnetic copy boards or copy holders may be purchased: those made for holding needlework instructions or copy while typing are good examples. The magnets must be large enough to hold the photographs securely, but watch that they do not cast shadows. The copy board should be dull black, or use black paper as a backing. The metal should not shine light or reflection back into the camera lens.

You must be able to move your photographs while positioning them for copying. It is much easier to move the subject than the camera. Select a copy board just a bit larger than your photo and the magnets so that it will be easy to move it around under the camera lens. This flexibility is necessary when you wish to include only portions of a photograph (called cropping), such as the selection of one person from a group. After you have tried your hand at copying you will know more what your needs are and how to improve your work .

8
Copying Photographs

Assuming you have everything required for the process of copying photographs, it is time to think about how to begin. You will need to consider each photograph before you begin the copying process. A good sized work table is useful for sorting photographs, taking apart photograph albums, and putting them back together again. I like to place "same type" photos together: same size, taken at the same time, same photographer, same tones and contrast. It seems to save time and effort.

Your pictures may include several different types of studio photographs. Most of the older ones will be cabinet photographs, or the smaller cartes de visite (used as calling cards 1859-1914). They were printed on single-weight (thin) paper and mounted upon a firm cardboard backing. The backs may be beautifully engraved with elegant, artistic, Victorian designs and calligraphy that may state the name of the photographer and the address of his photographic studio. There may be other photographic processes represented, such as daguerreotypes (ca. 1839-57), ambrotypes (1852-63), collotypes, and tintypes (1856-1938).

Many of the early photographic processes were named for the people who developed them. A mistake in the identification of a particular photographic process might be disastrous, should you attempt to take apart those that appear to be under glass. Generally, these miniature photographs can be photographed without dismantling. It is best to trust to experts any complicated cleaning or restoring process. If you do not have to take the photograph out of the frame, you need not be concerned with the type of photographic image it is. However, understanding the various photographic processes and the period of time during which they

were popular is a good way to help determine the age of a photograph. Should there be a revenue stamp on the back of a studio photograph, you may be sure that the photograph was taken during the time of the Civil War, since it was a special tax stamp to help finance the military. If the stamp is of any value, it will probably be worthless if removed from the picture.

Kodak has published several booklets on copying photographs. They are revised and reprinted periodically and are, generally speaking, available at camera stores or may be ordered from the Eastman Kodak Company. For those wanting to know more about the history of photographs, especially as it applies to the photographs in their collections, I can recommend: Thomas L. Davies, *Shoots, A Guide To Your Family's Photographic Heritage*, Danbury, N.H, Addison House (1977); Beaumont Newhall, *The History Of Photography*, New York, Museum of Modern Art (1964); and *The Latent Image*, also by Beaumont Newhall, New York, Doubleday (1967). Mr. Newhall and his wife Nancy were on the staff of the Ansel Adams Workshop, which I attended in Yosemete. Nancy Newhall coauthored, or coedited, many of Ansel Adams's beautiful books. The out of print books recommended above may be found in your library or located through inter-library loan. They might also be found in the holdings of state, or local, historical and genealogical societies.

The photographs with postcard backs were part of the postcard collecting craze that began about 1905. They were taken by both professional and amateur photographers using glass plate, or film, negatives, and were contact printed on heavyweight, photographic paper. Many of the postcard photographs were taken by itinerant photographers who clicked their camera shutters as they crossed the country traveling by rail, wagon, horseback, and early automobiles. Their studios and darkrooms were in such places as railroad cars, covered wagons, and tents. Occasionally, the photographers were accompanied by goats and carts, ponies and carts, or other more exotic creatures so as to attract children into having their pictures taken. For the adults there were painted backdrops or clever props to sit on or stand behind.

20 Camera copies of old printed and colored picture postcards

a Grand Army of the Republic Assembly, 1891. Harlan County Court House, Alma, Nebraska. The handwriting is that of my grandmother Sadler.

b Sailors' and Soldiers' Home. Grand Island, Nebraska. My great-grandfather, Samuel Sadler, was a physician-surgeon there in the late 1800s.

21 *a* A copy of a small tintype that was badly bent and discolored. The rough surface was difficult to photograph because there were more reflections to eliminate and distortion to contend with. In such cases, shut off any overhead lighting so that only the light from the copy lamps strikes the photograph's surface.

21 *b* Another copy of the same tintype. A dark blue filter (80 A) on the camera's lens helped to control the unwanted reflections It also helped to minimize the distortion from the bent surface. Notice the background detail, especially the rope at the right, which was not evident in 20 *a*. The black dots are more prominent in the above copy because they are no longer obscured by the reflections. They are caused by flecks of emulsion that have been peeled away from the original due to deterioration. The young lady is my grandmother Sadler in her high school theatrical. The identity of the young man is not known.

Postcards were collected by nearly everyone for a decade, and for many the hobby persisted after that period. Unique albums and embossed wooden boxes were especially made to hold the collections. The illustrated postcard bearing messages of greeting and floral designs was the forerunner of our modern greeting card. Scenic cards were popular collector's items, and pictured national parks and popular recreational areas. The "real photo" cards of street scenes, courthouses, churches, and places of business were also photographed by the itinerant photographer working his way from town to town. People who owned their own cameras photographed their prize possessions. Popular subjects were babies, children on ponies, places of residence, teams of horses, and prized livestock. Most of us have family photographs of this era, and many of us are old enough to have had our pictures taken by folding Kodak and Brownie box cameras, which were popular into the 1920s and 1930s. Turn over the pictures and probably you will see that they have postcard backs. There were even naughty novelty cards, some quite risque. World War I doughboys serving in France brought home some shocking examples along with postcard photos of war's death and destruction. One of the unusual, humorous cards in my collection is an actual photo of a two-story outhouse. The writing on the back stated, "Here's the picture I was telling you about."

Photographs in Albums

Photographs in albums are difficult to copy. If it is possible to take the album apart without harm, do so, but remember how it all fits back together again (*especially* if it's a borrowed one). If necessary, take notes and make diagrams on paper to remind yourself what it was like originally. Somehow this type of project tends to be interrupted; even a brief interval in a busy person's day affects the memory. At least it does in my case. I mean well, but it seems that my good intentions go astray as easily as my memory.

I would like to suggest that you photocopy or photograph the entire

album, sheet by sheet, as you take it apart. Photographing each page helps to assure accuracy in identifying the photographs should any come loose from the page where they belong. Written information about a picture would not be mistakenly applied to another photograph. Number your copy pages to correspond with the pages in the album, and include on the photocopies anything written or printed on the back of the photographs that have been removed from the album for copying. The photocopies (or prints) will be a valuable reference when it comes time to put everything back together again. This is something I wish I had done with the first albums I dissected. I thought I knew exactly what I was doing, but I didn't. I thought I would remember exactly how they all went back together, but I could not. You will find several uses for the small photographs. Place them on pedigree charts, family group sheets, index cards, or make a composite family photograph.

The plush Victorian Albums of padded velvet, popular in the 1800s, had slits to insert cabinet or cartes de visite photographs. The photographs may have been slipped into those slots easily at one time, but after many years of being unmolested they seem to be permanently attached. It is amazing how paper so fragile can defy you when attempting to remove it for the purpose of rephotographing. It is very easy to tear these album pages so be careful. If it wasn't for the genealogical information that might be found on the back of the photographs, it would be best for the album to be left intact; but if you are as determined to find every clue as I am, you will not be content unless you remove the photos. In one of our family albums my grandmother had written on the back of a photograph of my great-grandmother, "Mother's bobbed hair during the Civil War." Tweezers with wide corrugated points will assist you in withdrawing the photographs. *Carefully* insert the tweezers into the opening at the bottom of the photo. Grasp the bottom edge of the photo with the tweezers and with a gentle pulling motion remove the photo from the album opening.

Hopefully your photographs are in good condition. If they are not, you may need to find out how to restore and preserve them. If their ailments are minor and they need only slight cleaning, you may try a few home

remedies. For severe problems you may need the assistance of museum personnel who specialize in preserving and restoring photographic images.

Never throw away old photographs that are in poor condition. If they are dear to your heart, most of them can be restored. Those that are faded into near oblivion can possibly be saved by a special process of bleaching and redeveloping the silver image. Badly worn or torn photographs can be rephotographed, retouched, and airbrushed by expert hands into a new likeness. Never throw photographs away because you do not know the people in them. Make every effort to identify the unknown persons, and do not hesitate to ask for assistance from other family members. If no one seems to know the person in the photograph and no one wants them, give them to the photography archives of an appropriate museum or historical society. They may be of historical interest. Many persons collect such photographs. I am one of them. I have adopted the "home-

22 When photographs of historic interest are found in a family album you might consider loaning them to a historical society to be copied. Photographs taken by non-commercial photographers may be the only ones taken from that particular vantage point. The above photograph of Charles Lindberg's *Spirit of St. Louis* was found in my uncle Fred Sadler's album. It was probably taken in California.

less" for many years. They are an endless fascination to me, and speak of a time and an era that will never return.

Photographs that are curved will need to be flattened before they can be copied. Encourage them gently! Urge, don't force them into positions they are unwilling to assume, or they may retaliate by splitting the emulsified surface or breaking the cardboard backing. More drastic measures may be needed for the more obstinate ones. A slightly dampened cloth or sponge may help. After moistening the back, turn the picture face down, weight it lightly, and allow it to dry. If it is weighed down heavily, the emulsion may stick to the surface below.

If the photographs are dusty, wipe them gently with a soft, clean cloth, or a soft artist's brush. If gentle cleaning is not enough, proceed with care and caution. Remember that anything you may do in an attempt to correct problems may only compound them. Copies should be made of photographs that are seriously dirty before you attempt any type of water cleaning in case something should go wrong. Generally, these photographic surfaces are quite tough, but the emulsion softens with moisture and may become sticky or loosened from the backing.

If your photographs are pasted in albums, you will have to be extra careful as the black paper of which most album pages were made will deteriorate very easily, and the cotton or rag you use will transfer the black dye onto the photo. In her later years, my grandmother Sadler put together several albums of her old photographs. Her eyesight was no longer keen, and she used an ample amount of amber colored, household glue, or mucilage, which I used to call "Iron Glue." She did a very good job of gluing every bit of the photograph to the album pages. In fact, some of the glue seeped out onto the pictures' surfaces. Fortunately, it was water soluble, and I was able to remove much of the offending substance by rubbing gently with wet cotton. She also believed that photographs were for the family to enjoy. Evidently, her eight children enjoyed them a great deal as some had childish pencil drawings, ink stains, and lots of little one's fingerprints.

If you believe you can improve a photo by cleaning, I would like to remind you again to proceed carefully. Use a clean, non-porus working

surface such as glass or formica. Have a good supply of cotton balls and a large container of cool water. Dampen a cotton ball and, with a swiping motion, wipe the picture's surface. Turn the cotton ball as it becomes soiled. One swipe may be all it takes to make the cotton dirty. Your work has to be done quickly and carefully, before the emulsion softens. If the picture surface starts to get tacky, allow it to dry before continuing.

For the really grim grime, I used a soft, wet, and well wrung cloth that had been rubbed lightly on a bar of Ivory soap. I was able to be more thorough on the postcard photos than the mounted photographs, as I did not want the cardboard mounts to get wet. I gently (and quickly) wiped the photo's surface with the dampened, soapy cloth, then used another dampened cloth to wipe off the soap solution. With the postcard photos that were very soiled I used the slightly soaped cloth, then rinsed the entire card in cool water. I held it by one corner to drain and placed it face up on the top of a formica counter. I then used the flat side of my hand as a squeegee to remove excess water and allowed the photo to dry.

You may have to counteract the curl. Be sure to use Ivory soap, as other bar soaps may contain oils or creams. Detergents do not have the same type of cleansing action, not even Ivory Liquid. Water temperature is also very important. If the water is warm, the emulsion will soften more easily. Hopefully, you will not need to do anything this drastic. Perhaps a soft brush will be all that is necessary to clean most of your photographs.

In photographing album pages, consider each page as a large photograph. Because most of the photographs in albums are of the same size most of the copying of the individual photographs can be done with the camera at the same height. Even though the differences are slight, fine-tune the focus for each photo and change f-stops whenever necessary. You may wish to go as close as your lens will allow and zoom in on one person in a group or take a close-up of a face. This is the beauty of the macro lens.

Pictures under glass are also difficult to copy due to the reflection on the glass. If it is not possible to remove the picture from the frame to photograph it, try to avoid reflections, or use a polarizing filter. Try photographing pictures that are under glass from various angles. If your

eye can see the reflections, so will the lens.

Photographs mounted on a stiff backing, such as the cartes de visite or cabinet photos, are the easiest to photograph. Under the heat from copy lamps, however, even these will start to curl or buckle. Always remember to be very careful to protect any photograph from heat.

Copying with Artificial Light

If you have many photographs to copy, you might experiment with various light sources. Because artificial lighting can be either warm or cool in color, light may need to be corrected or accepted "as is" when using color film. With B&W film the color of the light source is no problem. You can combine the light sources and improvise to your heart's content, as long as whatever light you choose is the same on both sides of the copy area.

Fluorescent lighting is cool in color temperature compared to other light sources. It is also cooler to work with than incandescent. It spreads a broad pattern of light with few shadows, but the flickering of a fluorescent fixture may show in your photograph even though it is not apparent to the eye. Using two fluorescent lights, or a combination of fluorescent and incandescent, will help to eliminate this problem. Warm-light fluorescent bulbs, which approximate daylight, can be used with color film. If warm-light tubes are not available in stores, they can be ordered. Do not try to use "plant" lights as these are a different type of lighting.

Photofloods are similar to household floods, except that they are color balanced for use with color film. For critical color work, Number 1 photofloods are recommended. Photofloods have a limited life, and as their lives are expended, they change in color temperature. Because I generally use B&W film for copying, I prefer to use common household reflector floods. They are less expensive and cooler to use. I use 150 watt reflector bulbs in the gooseneck lamps mounted on my copy stand, even though being mounted on a copy stand limits somewhat the flexibility of arrangement. A better placement of light would be two gooseneck lamps on sturdy floor stands, placed on either side of the copy stand. An adjustable table top would be of use, as it is sometimes necessary to stand on

23 *(Left)* Gooseneck copy lights with polarizing filters attached.

a stool when the copy stand, in position for the copying of large photographs, is at its utmost height. Flexibility in arrangement is necessary so that you can put whatever light you are using where you need it. Stand-alone floor lights could be put to other uses: photographing people, heirlooms, and close-ups. I also use two gooseneck desk lamps with ten-inch fluorescent bulbs. Small tensor lights are useful when photographing small objects, small photographs, and for supplemental lighting.

To light your copy area properly, any light source must be at an approximate forty-five degree angle to your copy surface. The light source on each side of the copy stand must be identical in type and intensity. Turn off overhead lights, as they shine directly onto your subject and will give unwanted reflections. Should you plan to copy many photographs,

24 *(Right)* A copy stand with four lights is best for producing an even light.

you might consider copy lights that have the facility to add polarizing filters. (See chapter 6.)

Leave the floods off until you have composed and arranged your photographs and focused your lens. After the floods are turned on make any necessary changes in f-stops and focusing. Be sure to check the photograph and your camera *often* for overheating. Shut off your floods whenever you have to make adjustments in the height of your copy stand. If most of your photographs are of the same size, you will seldom need to make adjustments in the height (especially if you have a focusing rail). Check your focus *often*, even though the difference may be slight; fine-tune your focus and change f-stops when necessary. Make one exposure with your camera's reading and another with the exposure you get from your gray card. The heat from copy lamps can actually cause your photographs to steam, buckle, and blister. One of the plastic shades on my fluorescent lights has a disfigured corner, the result of melting when I accidentally pushed it too close to a flood. Do not leave lights burning when not being used, as some sockets not meant for flood lights may not be heat resistant.

Probably by now you have found out how difficult it is to maneuver an album to place the portion you want to copy under the lens in the precise position. There may be times when you will be unable to use a copy stand.

Copying Photographs by Available Light

Hopefully, on the day you must copy a photograph outdoors, you will have ideal weather conditions. Ideal weather for copying does not necessarily mean bright sun. Strangely enough, a cloudy, dismal sky is much better. The light is softly diffused and the possibility of troublesome shadows will be lessened.

Wind can play havoc with copying operations, even a slight breeze may spirit away your precious photographs. A sheet of plate glass laid over the pictures will help to keep them from becoming airborne, but then you may have to fight reflections from the glass. A polarizing filter helps reduce or eliminate such reflections. (See chapter 6.)

25 Page of family history book copied with a hand held camera using copy lights. *a (Right)* TTL metering with a gray card gave this exposure. *b (Below left)* The same page copied in open shade on my patio table with TTL metering. The camera was hand held. Photographs have reflections from an unknown source that could not be controlled. *c (Below right)* Another exposure taken on the patio. Meter reading was taken from the back of my hand instead of from the gray card, which was used with the above exposures. Being able to control the light source is a distinct advantage in copying photographs, but acceptable photographs can be made in makeshift situations.

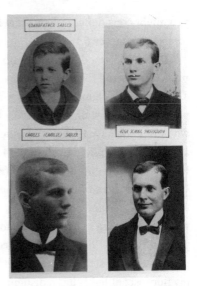

If you cannot pick the ideal day, find a spot on a porch, patio, or lawn, as far from the wind and hot sun out of the wind as possible. Find a flat surface to serve as your copy base. I have used tree stumps, patio tables, picnic benches, and sidewalks. If a picture is large and framed under glass, prop it against something substantial in an area where shadows are at a minimum. Try to keep your camera on the same plane as the picture you are copying. Move both yourself and your camera around and attempt to eliminate any source of reflection. Take several exposures with and without your gray card, and vary your position slightly. Glare is a problem indoors as well. Photographs with a shiny surface, such as glossy snapshots, can reflect nearby objects or unwanted light. A polarizing filter will help with these problems also.

If weather makes working outdoors impossible, you may have to settle for window light. North windows are best. There the light is even and shadows are unlikely. Place the photograph as near the window as possible at a height that will enable you to work comfortably. If you have no steadying support, you must take a firm stance and squeeze the shutter carefully. A medium speed film such as Plus X, ASA/ISO 125 should be sufficient.

As you journey through the recorded history of your ancestors, you must be prepared at any time to use your camera for unforseen opportunities. You will not want to miss out on recording anything that might be important to your family history, such as the photographs, maps, and illustrations to be found in books. Relatives will have photographs to copy. You may not always be fully prepared for these occasions; and there will be times when there is inadequate light and less than ideal copying situations. You must improvise and "make do" with what you have. The problem with insufficient lighting is that, in order to compensate, you must use either a fast film or a slow shutter speed. Both have disadvantages. Fast film is preferred to slow shutter speeds unless the camera is securely mounted. When you become more experienced and encounter different working conditions, you will learn which approach is best. After you have tried several different films and feel comfortable with your equipment, you will learn to work by instinct and with any kind

26 Family reunions offer the opportunity to copy photographs
of your ancestors.

This photograph, belonging to Pat Alexander of Tulsa, Oklahoma, was
copied at a Sadler family reunion in Keosauqua, Iowa. It is of an uniden-
tified woman and there is a possibility that she was our third great
grandmother. Pat's great grandfather, James Sadler, and my grandfather,
Samuel Sadler, were brothers. Because of the appearance of the woman's
eyes and the notation in our great-grandmother's Bible ("I am blind, Mary
Magdalena."), we feel that the picture found with other family photographs
may be positively identified some day. I copied it outdoors in the shade on
a cement slab. I used my Nikkormat FTN and 55mm Micro Nikkor lens
without any camera support.

27 Pictures I would not have were it not for my having a camera with me.

These photographs were on display at the 100th anniversary celebration of the Christian Church in Alma, Nebraska. I asked permission to take them outside to photograph them. I had color film in my camera and was without a flash. I laid them on the sidewalk and leaned over them to take the copies.

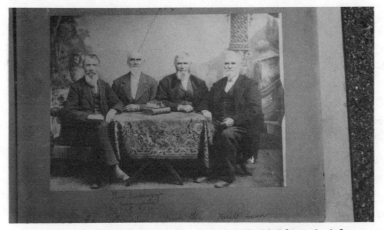

a My great-grandfather John D. Stevenson is third from the left.

b My great-grandmother Cecelia Augusta (Rice) Stevenson is third from the left. Her sister Julia is second from the left.

of light. Until then, try to prepare yourself for these excursions into the unknown. Take with you several different films of various speeds and, at the very least, a small tripod. Don't be afraid to make attempts at what seem to be impossible situations. You might be pleasantly surprised as I was with my first attempts at copying photographs from books in a library.

Before moving to its new facilities, the Family History Library in Salt Lake City had, next to its archives, a wall of narrow, north windows, which extended nearly to the floor. A ledge below the windows made a satisfactory work surface. I used other books for propping open the pages while I took my exposures. Most of the books you will be copying from will be old. Long rubber bands might be of help in holding pages apart while copying. Protect the edges of the pages by placing folded pieces of paper between the pages and the rubber bands where pressure from the bands might crush the old paper. Work slowly and carefully as the pages are crisp and fragile.

When you have found something you wish to photograph, explain to the librarian what you would like to do and ask permission. Librarians are generally very helpful, but they may frown on your setting up a lot of equipment. If it is a small library and there are few patrons, they might permit the use of a tripod or copy stand.

If possible, find a table where there is good light. If the light is poor, you might ask if there is another location that would afford more suitable lighting. Also, this may allow you to carry out your work without inconvenience to other patrons. In consideration of the existing lighting and your film's speed, calculate the slowest shutter speed you would be able to use without camera movement – if you are not going to use a camera support. Remember to use your gray card and bracket exposures. Keep records of your exposure data. Each of these experiences is another step in getting to know your camera.

If you have only a few photos, it may not be worth the time and effort it takes from your research to set up copy equipment. You must be the judge. Only you can decide how important the image is. When you are experienced you will know what is necessary in order to obtain a satisfactory image with your camera.

If there are other patrons, the use of a power-wind or motor-wind on your camera might be distracting and annoying. Think of the presidential press conferences and how the whizzing, whirring, whining winds distract you from what the President is saying. It probably depends on your political party preference on whether or not this is a bother to you.

Would it not be nice to be prepared should you find more ancestors than you've ever dreamed of, and, along with them, photographs that you never knew existed? Whether you are in a courthouse, library, or home of a relative, you will have the know-how to photograph right on the spot.

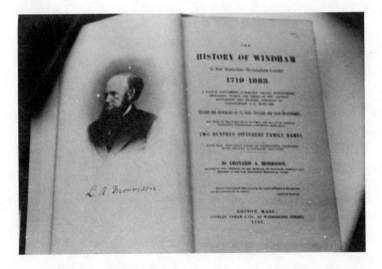

28 Photograph taken in a library. Notice the use of books for holding down pages.

9

The Photocopier, the Genealogist's Best Friend

A photocopier is the genealogist's best friend. I am equally sure that the makers of photocopiers and copy paper look upon the genealogist as something of a godsend. The amount of photocopying we do each day is astounding. I have great admiration for the genealogist of the past who had nothing more than paper and pen. How anyone could do vast amounts of genealogical research without a copier, I'll never know.

Some copiers are better than others at copying difficult subject matter. A letter of my great-grandmother's was barely readable, written with pencil on yellowed tablet paper. Many copiers have adjustable exposure controls, and by experimenting with the exposure, the photocopy might be made more legible than the original. The handwriting on my great-grandmother's letter was intensified, and the portions that were illegible before could now be read.

A copier may strengthen a dim photocopy, such as one made from microfilm, and render it more readable. Photocopies do fade, especially the older ones. It would be a good idea to recopy those that are fading, especially the slick paper variety, which were made on copiers with the wet copy process.

Sometimes the writing on the back of a letter or document shows through to the other side. To keep the unwanted writing from appearing on your copy, place a piece of black paper behind your original. It should help to prevent the writing from showing through so that the copier will not reproduce it. Despite many improvements, copiers still have difficulty reproducing photographs. Copy machines are designed primarily to copy printed matter of one tone, or line drawings. Photographs are con-

29 Example of a letter made more legible after being photocopied.
This letter, written by my great-grandmother Cecelia (Rice) Stevenson, had yellowed and grown brittle. By reducing the size and adjusting exposure on the photocopier, the handwriting was made darker. Many letters such as this will be lost unless reproduced in some manner.

tinuous tone images, made up of various tones of grey, which range from white to black. One difference between copiers lies in the way in which they reproduce the tones. Some copiers produce copies with more contrast than others. A screened photograph may reproduce better than one that has not been screened.

When a newspaper or magazine reproduces a photograph, it is rephotographed by a process that converts the continuous tone into tiny dots so that the printing press can reproduce it more accurately. A similar but not as effective an aid is available for use with photocopiers. This consists of sheets of transparent plastic upon which dots of various sizes have been printed. The size of the dots depend on the size of the photograph and the degree of enlargement to be made. The sheets can be purchased at office supply companies. Do not buy those designed for graphic artists. Generally speaking, these sheets incorporate black dots; and they are meant to be cut and peeled apart for illustrations. The screens are placed on the copier's surface between the photograph and the glass. The screen should improve the copy of your photograph, but you may be need to experiment with different sized dots and exposures. Some photocopying services will provide the screens. If you wish to have your photos professionally screened, inquire at your local newspaper office or a printing company. They will be able to give you information on such a service.

Photocopiers can be used to design charts and genealogical forms or to modify others. If you do not have the form you need, why not make your own? You can reduce your forms to one half, either before or after filling them out. You can reduce the size of your pedigree charts to fit the size of the various notebooks that you are using. For those who may want to issue a limited edition of a family history, the photocopier can be your printer. You can type your manuscript, add photographs, use pressure type, transferrable lettering for chapter headings; and you can correct all sorts of mistakes with correction fluid and self-adhesive correction or cover-up tape such as that made by Avery and 3-M. Most office supply and printing companies have binding machines for soft bound books such as velo binding, sometimes referred to as "saddle bind-

ing." A velo machine punches oblong holes in your printed sheets for a plastic "saddle" spine. There is no reason, other than a few dollars copying charge, why you cannot enjoy the pleasure of your own published family history. Even if your editions are only half a dozen copies, it is a rewarding experience to see the results of your research in the form of a book. You can revise, supplement, and reprint anytime you wish.

If your objective is set on a grander scale, involving anything over fifty copies, check with your local printers for their prices on offset printing. It might be wise to consult them at an early stage for suggestions as to how to make a better book without complicating the printing process. Also, there may be a wide difference in prices between the different printing companies. Price would also depend on the number of books printed, the paper used, and the type of binding. You might consider acid-free paper to insure the longer life of your books. Depending on the number of pages, a printer may charge less than what it costs to photocopy. You may also wish to consider having a printer prepare only the pages containing photographs. In any event, if you plan to print your manuscript on a photocopier or submit it in "camera ready" form (finished copy to be photographed) to the printer, you will find the photocopier of great assistance.

30 Photocopy screen

Before you begin to type your manuscript, check your local library for books that contain in-

31 The photocopy screen on the facing page is a 30% screen with white dots. A 10% screen has smaller dots than a 20%. Anything larger than 40% would be too large, and 10% would be too small. For normal use, consider 20-30%. The screens can be purchased with either white or black dots. I prefer white.

The pictures on this page were photocopied with a 30% white dot screen.

a Photocopy of a professionally screened photograph

b Photocopy of photograph without screen

c Photocopy of photograph using photocopy screen

formation on how to prepare a manuscript. If a publisher is not going to typeset or prepare your manuscript for you, it will not be necessary to type in double space. One very important thing to remember is to leave plenty of room for the margins. Neither the printing press nor the photocopier is able to print up to the edges of the paper. Leave at least an inch on all four sides for margins, even more on the side of the page to be bound or punched. If your pages will be printed on both sides, allowance for binding will need to be made on every page. Check with your printer if you are having it done professionally. If you are not sure how a page will look printed by offset, copy it first on a photocopier. If you see places where the edges of an illustration or pasted image show, you may need to repaste or use white correction tape over the seams. Some copiers conceal such faults very well; others may show shadows at the pasted edges.

If you will be using your master copies off and on for a period of time, do not use rubber cement as an adhesive, since it yellows paper very quickly. White glue such as Elmers works well with photographs, but wrinkles paper. Use only a micro-dot on the photograph's corners. For paper, I like the transparent craft glues such as Itoya O'Glue. It is in a long, transparent tube with a sponge top. Use just enough to stick, and spread it evenly. Lay whatever you are pasting on a piece of paper and, with your finger, push any excess glue off onto the backing paper. Do not worry if you have minor wrinkling or curling, as the photocopier will make it look fairly professional.

Once you get into the publishing business as a do-it-yourself printer, you will think of many things you can do with that object of photographic delight, the photocopier.

10
Capturing the Graven Image

Lighting is very important in tombstone photography. As it is not customary to move tombstones to better light, we must cope with the light that's there. In summer there is usually dense or spotted shade. In winter the shadows of branches or adjacent stones may obscure an important part of a name or date.

If you live near the cemetery relevant to your research, or are going to be near that area for a few days, take photographs of the stones at different times during the day. Lettering that is difficult to read – much less photograph – might show up better when light strikes it at a different angle. Photographs that depend on angles of light to delineate such things as the outline of lettering should be taken during mid-morning or mid-afternoon.

Most SLR cameras have through-the-lens metering systems that measure the amount of light which reaches the film. This assures you that the exposures are as accurate as possible. If your camera is new, it may also have a spot metering system. A spot meter reads a small, important area of the subject you wish to photograph so that that portion of the photograph is properly exposed. This feature allows you to stay in your shooting position and to take the meter reading from a distance.

Do not let your camera "read" the sky when photographing a cemetery. Lower your camera lens so that it reads the ground, or the darker tombstones. Use those readings for some of your exposures. Shoot for the shadows, in other words. If your meter reads a bright sky, your camera will probably underexpose the tombstones. The stones in the shade and shadow areas may be illegible.

This would be the right time and place to use a gray card. Because tombstones vary in color and the lettering varies from easy to read to very difficult, you should be precise in your metering of a particular tombstone. Place the card in an upright position against the stone. Take a reading with your camera's exposure meter. Note it, then take a reading laying the card on the ground next to the stone. Take several pictures within this exposure range. Both highlights and shadows should be properly exposed.

If your camera's exposure system allows, you may be able to take a close-up meter reading with your camera, then step back to your desired shooting position to take the exposure. You might take readings against both the lightest and darkest parts of a stone, and then take your exposure with a mid-point or average reading. This would give approximately the same reading as does the gray card because it is an average reading. To be absolutely certain that you have tombstone inscriptions that are legible in your photographs, bracket several exposures above and below the average readings.

Correct focus is also important. Be sure that the most important stone is correctly focused. A wrong camera angle might allow portions of the inscription to be photographed out of focus. As you look through your camera's viewer, move to the left and right, and up and down; consider various angles. Shoot the scene that looks the best through the viewer. Take at least one exposure with your eye level at the middle of the engraving. This will reduce the chance of one portion of the engraving being out of focus. Do this wherever possible.

Depth of field is also important. Many things affect the depth of field: lighting, distance, aperture, shutter speed, film speed. It is important to understand how and why. Your camera should have a depth-of-field scale on the lens, which will tell you whether an object is within a certain range. A cemetery is one place at which an automatic focus camera might have a nervous breakdown, as there are so many surfaces and so many distances for it to decide upon.

Be sure to have medium or fast film on such trips. You may need the extra speed, especially if it is quite early or late in the day. If the light is

dim, if your film is slow and you do not have a tripod, don't despair! There are many props in a cemetery. There are tombstones to rest your camera on and trees to lean against. If you have a bean bag, small pillow, or a towel, use it as a prop upon a tombstone. It will protect your camera and provide a buffer against motion made when the shutter is released. If you have enough light, you can use 1/30th or 1/60th of a second shutter speed as a starting point. You may have to go down to 1/15th. Lean against a tree, stone, or whatever is available. Hold your breath, and push the shutter *carefully*.

If the stone is old and very worn, there are a few things you might try to make it more photogenic. First take a few shots of it "as is." If possible, take along a cemetery kit. A few items that you might include are: a knife, whisk broom, trowel, grass shears, scissors, chalk, old rags, shaving cream, a squeegee, flashlight, and a container of water. Don't forget a clipboard, paper, and pencils for writing exactly what is written on the stones. There may be more items to include if you have room. Try to provide for any emergency.

Sometimes a stone needs cleaning or brushing – birds do have a way of leaving telltale evidence. *Never* do anything destructive, use nothing more abrasive than a whisk broom to clean the stone of dirt and debris. If grass and weeds have grown up around the stone, use your scissors or shears. If the stone is sunken, and soil or sod obstructs the writing, use your knife or trowel to remove the offending portions of soil. Whisk off anything remaining on the stone. Shoot your pictures and replace the soil.

If necessary, enhance the engraving by rubbing the flat edge of a large piece of chalk lightly across the surface of the stone. Another thing that works well is a can of shaving cream. Fill the depression of the lettering, then squeegee the excess from the stone's surface. The shaving cream stays within the incised lettering. Do not use pencil or crayon on the stone. Use nothing that will not wash off with water. Incidentally, that's what the can of water is for. A powdered chalk called pounce, flour, corn starch (or a similar ingredient) tied in a cloth, then pounded or rubbed against the stone should provide a sufficient contrast between the lettering and the stone's surface to improve the readability for a photo.

Have you ever noticed how lovely the designs on tombstones are? They are a study in themselves. Incidentally, the names on tombstones can be misspelled, and a date may be wrong. Research may be the only remedy.

If you like, make a stone rubbing. Use freezer paper (we used to call it butcher paper) the kind butchers used to wrap meat in. Kraft wrapping paper, such as grocery sacks are made of, works well. Use the flat side of an unwrapped jumbo crayon, (or something similar) over the well-secured paper on the stone. Take along plenty of crayons as they will not go far. An assistant would come in handy as it's an awkward, difficult job – especially if you have to straddle iris or a rose bush.

As long as you have plenty of room in the car, be sure to take along your "cemetery medical emergency kit." Include antiseptic, bandages, and plenty of insect repellant.

32 This photograph shows that patches of sunlight can wipe out a stone's legibility.
If possible take photographs at different times of the day to insure that the lighting will be effective.
Meter carefully and bracket several exposures.

33 *a* Take several photographs of general area stones. Surnames of people buried close to your ancestors may be significant. This picture was taken in Florid, Putnam County, Illinois.

33 *b* Proper exposure is essential to get the best from both the highlight and shadow areas. To have all the various subjects in focus, you must learn about depth of field. Certain distances within the focusing range can include many subjects clearly. This picture was taken in Bader, Illinois.

34 Vegetation can be vexing to the tombstone photographer.

35 Examples of chalking in order to make inscriptions more readable.
These pictures of my ancestors' stones in Windham, New Hampshire, were
taken by Mavis and Dale Frandsen.

36 The importance of detail

a (Right) Joseph Cassell's tombstone showing the side dedicated to his wife Sarah Ann (Lynch) and their son George Edwin Cassell. A macro lens close-up should have been made of that part of the inscription between "26 Y's" and "George Edwin," but time did not permit.

b (Below) Joseph Cassell's children's stones. Even though epitaphs do not always contain genealogical information and it was not known to which of Joseph's three wives the children belonged, I should have made macro lens close-ups of the stones. Again, time was the problem.

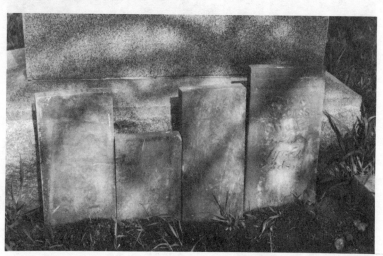

37 The small metal markers placed near a gravestone may offer a clue to a person's military involvement. Should "G.A.R." be on a marker, it means "Grand Army of the Republic." That person served in the Civil War. There are variations on these designs especially made for an area or post. There are special shapes of markers for the various wars. There are also special markers for the Ladies Auxiliary and Daughters of the American Revolution. World War II and recent military campaign markers may be plaques.

38 Decorative detail on stones can be of value in the information you are collecting.

39 This elaborate memorial in Hiawatha, Kansas,
depicts several stages in the lives of a husband and wife.
The above photograph and those on the following page
show some of the statues that surround the crypts.

The pictures were made with a 2 1/4 square, twin lens
camera with an old light metering system. I placed a
finger over a portion of the light metering window in
order to offer increased exposure for the shadows. Fool-
ing the meter in this way forces automatic exposure
cameras to work harder; therefore, more exposure is
provided when it is needed. This is desirable when it is
obvious that much of the area to be photographed is in
shadow – greater depth and detail are achieved. Newer
cameras are more competent in creating the ideal over-
all exposure, but there are times when it is helpful to
fool them also. Creative printing would also provoide
finer detail than would be evident in a straight print.

40 Settings such as this make it difficult for any type of
 exposure system. Bracket your exposures.

11
People Pictures

We must not forget the living. Photograph those in your family circle as soon as possible. Time is valuable when you are trying valiantly to compete with it. Procrastination allows days to slip by, and loved ones become ill or are lost from our lives. Why tempt fate and risk missing other opportunities that may never return? Get on the phone or write a letter! Decide *now* to take those photographs and interviews that are important to you and to your family history. Today isn't too soon!

Photographing people is more difficult than photographing inanimate objects. Making successful "people photographs" is even more difficult. Every family has members who are camera shy or downright unphotogenic. Some seem always to close their eyes or open their mouths when the camera's shutter clicks. Others tend to look upon the camera as an enemy to be reckoned with, and the results can be grim. I have always contended that (with some exceptions) our family consists of fine looking people who take awful pictures.

Photographing Individuals

Before you begin to photograph, you might try to initiate a good mood, especially if your subject seems somewhat reluctant. You might explain that the pictures are important for your family history book, and that they will be allowed to select the ones to be published; and offer them free copies of the photographs.

If a person is unwilling to be photographed or tape recorded, there is nothing much you can do except to attempt lighthearted conversation about anything and everything. When you feel that the time is right, you

might start asking family questions again. Hopefully, your subject will tolerate the shenanigans which are a part of your photographic interview. If not, you must consider their feelings. Do not insist! Do not thrust a camera or microphone in their face and expect them to act as if it were not there. Try to make these recording devices unobtrusive; and act as natural as possible. Make your interview a conversation rather than an inquisition.

You might ease into your picture taking slowly. At the start of your visit, place your camera on a tripod and set it aside. Converse for awhile before starting to photograph, unless your subject is anxious to have his picture taken. Expect a variety of reactions as you photograph individuals. There will be those who are hesitant about having their pictures taken, and others will be unbelievable "hams."

People and Personalities

Personality is an essential ingredient in the photographs of loved ones. Make every attempt to take pictures that will allow the personalities to show through. Watch for a particular facial expression or gesture, and be ready to click the shutter when it appears. You might include in the photograph something important to that person. If there are pets, include them. If the subject's spouse is deceased, you might include the loved one's photograph somewhere in the picture, perhaps placed on a table by the subject. If Aunt Minnie is a quilt maker, picture her with a quilt on her lap and her fingers inserting the needle into the fabric. While her face is intent in what she is doing, make a few exposures. Catch another expression as she looks up smilingly from her work to answer a question about a favorite child, who is now long past their teens. Ask a provocative question in your interview, and be ready for the response and its accompanying facial expression. If auntie is known for her sly winks or hearty laugh, try to capture her in the act. These are the things you will remember about her, and which you will remember the longer with the aid of a picture. That wink will be held for members of the family who will never know her.

Cecelia Augusta Rice
Born 30 Aug. 1829 Worcester, Mass.
Married 24 Sept. 1846 John Dinsmore Stevenson
Died 29 Mar. 1907 Alma, Harlan Co., Nebr.
Daughter of Colonel Jonas Rice & Orata Partridge
mother of Eliza Jane (Humphrey), Julia Augusta (Alter)
John Dinsmore Jr. Jonas Rice, Clara Ella (Humphrey) Lewis
Emmons, Sherman Ellsworth, Nellie Isadora (Sadler)
Seldon Sumner, Ada Bell (Nahn)

written on back of photo "Mother's bobbed hair for
Civil War "

my great-grandmother
Wilma Skull

Samuel Sadler M.D., son of William
& Catharine Sadler, born 29 Nov. 1834 in
Tuscarawas Co., Ohio. married Frances
Nutter in Bucklin, Linn Co. Mo. after Civil
War where he had served as hospital steward
in military hosps. in Mo. He became physician
-surgeon after studying medicine in Keokuk
Iowa. Moved to Hastings, Ne. 1873 where he served a term
in Nebr. State Senate. To Alma, Ne. 1881. One child (Charles)
born before going to Nebr. Wife Frances died when Charles
was a young man. Samuel to Grand Island, Ne. ca 1898 to
become physician-surgeon at "Soldier-Sailors Hosp." where
he married 2nd Emma Covert, child Clay born
when father was 68 yrs old. -Baby died. over

Clara Delia (Stevenson) Humphrey
Born 11 Feb. 1852 Denmark, Lee Co. Iowa
Married Edwin Humphrey
Died 26 Nov. 1857

Daughter of John Dinsmore Stevenson &
Cecelia Augusta (Rice)

Sister of Grandmother Nellie Sadler-(W.S.)
Edwin Humphrey's brother Charles S.
married Eliza Jane Stevenson - Sister of Clara
resided in Belleville, W.Va.

41 Use small photographs for your family group sheets and pedigeree charts.
I find it helpful to make file cards of the people whose photographs are in
my possession. This is important when the photographs are of people long
deceased and from large families. In years to come it may aid my family in
discovering "who's who" among the confusing "look alikes" of ancestors'
brothers and sisters. These cards will serve as an aid in preparing my fami-
ly history manuscript.

Does Uncle Henry have a hobby? Oh, he has a barbed wire collection? By all means show Uncle Henry that you are interested in his collection. Photograph him beaming with pride as he stands beside the boards mounted with rare barbed wire, which dates back to the early cattle country days. Work to capture those special qualities in a personality and you will have a successful picture.

Backgrounds

Backgrounds are very important in people pictures. Generally, backgrounds for portraits should be plain, not cluttered or distracting. An uncluttered background gives a figure more importance or emphasis, but if a background can add something to the personality of the subject, by all means include it. Take time to position the camera in the most advantageous position. Make the background as complimentary to the subject as possible. If it is not possible to do away with a background, at least move your camera so that objects behind the subject do not appear to be a part of the subject. Take care that a lamp shade does not resemble the hat on grandmothers's silver tresses, or that the deer's antlers on the wall do not appear to be growing from Uncle Henry's head.

Putting a Little Light on the Subject

The amount of light falling upon a subject determines whether a photograph will be good or bad. How light strikes an object will make a photograph dull, dramatic, or defective. The angle of light is almost as important as the amount. Whether you have enough light will depend on several things: the speed of a camera's shutter, the speed of the lens, and the type of film. It also depends on how you use your equipment and whether you are using a camera support. Generally, be concerned with normal conditions, yet there may be times when situations arise that are beyond your control. There will be times when the only light you have is that which is available; and there will be times when you have nearly used

up your supply of film, and the only film left is not suitable to your needs. If you have to depend on available light or the film in your camera, you must do some fancy finagling with the camera's exposure system. If you have a tripod, you will find it easier "robbing Peter to pay Paul." You can subtract from the shutter speed and add to the lens opening. If you do not have a tripod, you will need to learn how to juggle the camera's shutter speed and lens opening until you find the proper combination for that particular exposure.

Available light is either artificial or natural. It is the light "that's there." Quite often you must use whatever is available if you do not wish to resort to an unnatural source of light. Your camera's flash may not do justice to what you are photographing. Light varies in color and intensity depending upon the source. It gives form and substance to a subject. Whether you must depend on natural or artificial light depends on the circumstances existing at the moment you choose to make the photograph. Most of the time, available light is sufficient. If it is not, you must improvise or make more light available.

Pieces of white material, cardboard, poster board, even aluminum foil, can be fashioned into reflectors. Place them opposite your lamps where they will bounce the light onto your subject. Back a piece of white posterboard with foil and you have a choice of a hard or soft reflector. The foil will give a stronger reflection, but may be too harsh for delicate subjects and many portraits. If you are outdoors in a park, someone might hold a sheet to bounce sunlight onto the person, or persons, being photographed. Use whatever method you can to fill in light or even out the shadows.

If you are in your own home, gather together the portable lighting equipment that you acquired for other photographic uses. Arrange them any way you wish to make the light as pleasing as possible. They will give better lighting than the flash from your camera. If you are in someone else's home and it is possible to arrange the lighting, do so. That is, if your hosts are agreeable – and you don't knock over the fish bowl while doing it.

A camera's strobe (flash) detracts from the natural appearance of a

subject. On-camera flash is difficult to control, especially in close-ups. Those color prints of people with red eyes are the result of on-camera flash: the flash was too close to the lens. If you must use the flash, instruct your subject not to look directly into the lens. The camera's flash can be valuable as a "fill-in" light when taking pictures of people outdoors in either daylight or insufficient available light, particularly in dense or dappled shade. Consult your camera's manual for specific instructions regarding camera-strobe combination. Strobe lighting is another automated feature that continues to be improved. If your camera is new and you have a dedicated strobe (one designed especially for your camera), it may have a sophisticated light measuring device that sets your aperture automatically.

Lenses for People Pictures

Your normal 50mm lens, or your macro, will be fine for one or more persons, even a small group. A medium telephoto lens, such as a 90 or 120 length, enables you to shoot portraits from a normal distance without any distortion of facial features. You will not need to be under your subject's nose to take a portrait shot. The 35mm medium wide-angle lens is ideal for taking large groups of people without the photographer backing up for half a block in order to include everyone in the viewfinder. It is also useful in close quarters, such as in a small room. Remember that this lens may distort nearby objects. If the camera is on a tripod and a cable release is used, you may sit comfortably nearby and squeeze the release at the right moment. Should you also have a motor wind, you could remain seated and not have to interrupt the session for the purpose of setting the shutter manually.

Family Groups

A successful family group photograph with everyone looking their best is akin to baking an acclaimed cake from an impossible recipe. It will be a miracle if you can catch each member of a family group in a pleasing pose for posterity. It is inevitable that someone will not be happy

about how they look in your photographs.

There may be many things that thwart family group pictures from the start. To name a few: inclement weather, the wrong kind of background, the wrong kind of lighting, uncooperative family members, missing family members, the wrong photo accessories for the right camera, or the wrong camera for the right accessories.

Before you gather the flock together for your photo session you might do a little planning. Announce that at a certain time and place photographs will be taken. Allow a respectable time for the group to fix their faces and groom their hair. You may have to ring a bell, honk horns, or become very vocal when the time comes to assemble. Plan for the photographic session to take place before the group has their picnic or dinner, especially if it is a holiday. That will be difficult, but after a big meal everyone becomes laid back and lazy. The kids are dirty and the adults too tired to drag out their cameras.

Lining up individuals for a group picture is about as frustrating as trying to get a fly into position for swatting. There are several choices, but you may not get the chance to make them. The number one choice is to stand everybody up like ramrods, shove them close together, have them say cheese, then shoot. The number two choice is to have some stand, others sit, and some kneel. Number three choice is to divide the group into sections (brothers and sisters, aunts and uncles, in family groups, or by generations). Choice number four is to hire a professional photographer whose professional equipment will allow the entire group to be easily photographed at once. The last way is probably best, as you can sit back and relax and not have to take the blame if the photograph of the entire tribe is no good. Whatever your choice, strive for good lighting and good composition. Whether your groups be large or small, make sure that plenty of exposures are taken.

Holiday Time

Before the advent of another happy holiday with your family, give a thought to the kind of pictures you will take. Prepare your photographic equipment well ahead of time so that the rush of the holiday season will

not turn it into a last minute grab of the camera and some film. In fact, you could forget to take your camera altogether in the hubbub. If you are familiar with the surroundings of your family get-together, you might make mental notes concerning a room that would provide an area with a suitable, uncluttered background. If the family holiday celebration is to be held in your home, you might arrange a "home studio" by removing a few pictures from the wall, rearranging the furniture, and supplying supplemental lighting. If yours is a typical family, the furniture will be re-arranged anyway, especially if there is to be a football game on TV. Some-how, life seemed to be simpler in the days before television.

Also, give a thought to picture subjects. Think of the role models at your family get-together. Who usually sits where at the dining table, who carves the turkey, and who says the blessing? Is it traditional for Dad to carve the turkey? If so, photograph him at his carving. After the blessing is said, ask the person who spoke the blessing to pose for a photo. You might tell the person ahead of time that you would like for them to recreate the scene immediately afterward. You might then photograph the persons on each side of the table and at any other tables. When the meal is over take several shots of the dishwashers, TV watchers, and children at play. Keep your camera handy for the unexpected, like dad falling asleep watching the game, or the dog eating Rachael's doll.

You might try tape recording these holiday gatherings. As for our family, everyone talking at once is traditional. The recordings we have made while opening Christmas presents are hilarious. They are filled with so many *oooos* and *ahhhhs*, and everyone exclaiming at the top of their voice to the extent that it is difficult to tell one voice from another. Yet, that's our family! They are loved, each and every one. Not so the photographs. There are several members of our family who complain that they do not look like their pictures – and sometimes they are right. If nothing else, the candid shots will be good for a laugh for generations to come.

12
Photographing Your Heirlooms

While assembling your family history in order to preserve it in the form of a book, why not include pictures of family heirlooms? Photograph those in your possession as well as those of other family members. Gather as much information about each heirloom as possible. To whom did it belong, or who had it originally? Who made it?

In another generation any knowledge of those heirlooms may be lost. There may be no one in the family who will know to whom the old "family chair" originally belonged. Unless future generations know of its importance, it might go to . . . wherever it is that old chairs go when they expire. If there is a picture and story about it in your book, and if those who will inherit know that their great-great-grandfather sat in that chair during precious moments of his later years, this heirloom will have a special significance for them.

There are often interesting stories in connection with heirlooms. We all know what can sometimes happen to people's memories. They can become lost so easily and so quickly. We all know what becomes of possessions. They grow older and older until they are gone. Preserve the memories in writing and heirlooms in photographs.

The hand-me-down furniture your folks gave you when you started housekeeping will someday be antiques. Possibly even now. You have kept that furniture all these years for sentiment's sake. Your parents may not have thought to tell you that those pieces of furniture were what they started out with too. They may have told you, but you have forgotten. That is the way memories are, and that is why it is so important to keep a family history.

When we are young, we often do not appreciate such things as heir-looms. Each one of us has regrets of something we did, or did not do, concerning something in our possession. It is not until we grow older that we realize this. When families get together, we hear conversations that go something like this: "I wonder what became of that blue onion china that grandma had?" "Who knows! I suppose it was all broken long ago." Or, "Oh, how I wish I had appreciated the value of that quilt Grandma made for me. I would not have subjected it to such heavy use, even though we were in need of bedding then."

It is easy to reproach ourselves for past carelessness when in our mature, thoughtful years. Family heirlooms may have been used to near extinction because of necessity. However, if an object was cherished, no matter how impoverished a person might be, that object would be cared for, saved, and passed on. It is these cherished possessions, the lovingly preserved family treasures, that should be photographed and written about. They speak of an era. Future generations must have an appreciation for the things they possess before they have sense enough to take care of them. Let's hope they appreciate ours.

Almost any camera can be used to photograph objects of average size. It is when those subjects are tiny or very large that there is a problem. The lens used would depend on the heirloom's size. A medium-length, normal lens should suffice for heirlooms of average or large size. A macro is ideal for the tiny items, and a 35mm wide-angle is just the thing for quilts. If you are not equipped with an array of lenses for each and every need, you need not feel defeated. Do not hesitate to photograph something not ideally suited to the lens you have. Give it a try. You might be surprised with the results.

Place your heirloom on an appropriate table, box, or other firm foundation. If the background is not suitable, use a piece of posterboard or cloth behind it. Walk around and frame the object in your camera's viewer from various angles and levels. Try to visualize how the finished picture will look. Is there enough contrast between the background and the object? Does the area that surrounds the object distract? Background and lighting are perhaps two of the most important elements in

making a good picture of any subject. The background should not distract but should be plain, providing suitable contrast.

Lighting Your Heirloom for a Photograph

The lamps you use for copying and photographing people are fine for photographing heirlooms. The same table lamps, floor lamps, or desk lamps can help illuminate your heirlooms. You might even enlist a flashlight. The small tensor lamps should be adequate for tiny items such as coins, jewelry, buttons, and miniatures. Arrange the lights at right angles to emphasize the engraving or bas-relief. Move them around to find a position that illuminates the subject to the best advantage. The reflectors that you devised for photographing people may be even more helpful in lighting heirlooms.

Is there enough light to enhance an engraving? Have someone move the light or the subject until you are certain the shading is exactly what you want. The lighting that is right for one subject may be wrong for another. Let shadows play a part in the delineation of a shape. Lighting from an angle will be better than straight-on lighting. Also, it is best to use more than one light source.

Avoid using flash! Seldom is camera flash used in small object photography. It could wipe out detail and cause reflections in dishes, silver, and crystal. If you place your camera on a tripod, or other firm support and use sufficient light (or a fast film) you will not need flash.

If all other systems are "go," such as your exposure, the right shutter speed and f-stop combination, you are ready. If your camera is sitting securely on a tripod, or if you have become proficient at holding still, shoot! Take several different exposure/shutter combinations. Go a little over or under what the meter says.

Photographing Quilts

Quilts are difficult to photograph, especially an entire quilt. Getting far enough away from the quilt in order to include all of it is often a dif-

ficult task if attempted within the confines of an average room. A 35mm medium wide-angle lens on your camera would be helpful. A wide-angle lens would give you a wider (angle) view and would allow you to photograph the full quilt. It is difficult to arrange a quilt to be photographed, and a public building can offer the answer to your dilemma.

Locate a building that has an open stairway or balcony. Two or more persons can hold the quilt, allowing it to hang down over the side. Churches and schools with their platforms, stages, choir lofts, and podiums may provide the expanse you need.

Try several exposures at different apertures. Flash at such a distance may not illuminate the quilt evenly, perhaps not at all. In taking a close-up of a section of the quilt, you may discover that flash can overexpose the pattern. If the building has sufficient light, you may not need flash. The best bet is to use a fast film and a tripod. Have your quilt-hanging helpers hold very, very still. If the quilt has an allover pattern and it is not important to photograph the entire quilt, try hanging it over a clothesline or fence. It is most likely that you will want to photograph the entire quilt, but you will thank yourself if you include a close-up of a quilt block or a part of the pattern.

To photograph a quilt while it is hanging, sew loops or a long strip of fabric on the backing at the top. Try to distribute the weight of the quilt evenly so that the portions supporting the quilt are spared any strain. Be careful in stitching and do not sew into any quilting stitches.

Hang the quilt from a rod or nail it to a wall by the loops or supporting strip. If it must be nailed to a wall, you will have to search for a wall where nail holes are no problem. You might take the quilt outside on the shady side of a building and tack it by the loops to the siding. If you must use the sunny side of a building, be careful of shadows. Also, keep in mind that direct sunlight is a danger to fabrics, especially when they are old and fragile.

If nail holes in the siding are out of the question, there is an alternative: drive out into the country and look for an abandoned farm building. Faded, weathered wood makes an ideal background for quilts. Find the side of the building across which light is spread evenly. You will probab-

ly need a small stepladder and at least one helper. A very tall person will come in handy when it comes to the tacking.

Well, that's about the size of it! Remember that these heirlooms will not last forever, but what you write about them and your photographs might. They may be preserved forever by being photographed and rephotographed. Isn't it worth the effort? Time and nature can be real killers. Photographs of your heirlooms and copies, or negatives, of your family photographs could be placed in a bank vault along with your insurance papers and other valuables. After my home town's (Grand Island, Nebraska) horrendous tornado on 3 June 1980, in which hundreds of people were left homeless, the most bemoaned of lost personal possessions were family photographs and heirlooms.

These are important objects that you will photograph, so make sure to take more than one exposure, especially if you will not have the opportunity to do it again. You will never quite learn what to do in a given situation as there are too many variables. You must do the experimenting and learning. It is important to keep a record of your trials and tribulations, your successes and failures. They will all be valuable, especially as a starting point – the next time.

Each of these photo taking events is a learning experience. You can train your eyes to be "photo conscious." Learn about composition, balance, color, and value, each of which can make a difference in the quality of a photograph. Train your vision to see pictures. Make a rectangular opening in the center of a piece of cardboard and use it as a viewer. The hole should be approximately the same proportion as a frame of 35mm film. A rectangular window twice the size of a 35mm slide should be about right, although a somewhat larger or smaller opening of the same format will do. The frame around the window should be sufficiently wide so that when held to the face the frame will obstruct your peripheral vision, thereby preventing your being distracted. Hold it close to your eye at first, then slowly move it back and forth and from side to side. Notice the effect upon the composition within the viewer frame. Take your viewer outdoors and walk around looking for pictures. If you are afraid that your neighbors might think that strange things are hap-

pening to you, take an automobile ride in the country and view to your heart's content (not while driving, of course!). Before long you will be able to see pictures everywhere, with and without a viewer or camera. You will have photographs to be proud of, and you will often say to yourself, "That would make a great picture! I wish I had my camera."

13
Traveling with Your Camera

Traveling with Your Camera by Car

The worst thing that can happen to your camera while traveling is to have it stolen. The next worse thing is to cook it to death. How would you like to be left in a car in hot weather, especially without some sort of protection and for an extended period of time? The camera and film can be harmed, perhaps permanently. Film will be the first to suffer; it will become sticky and perhaps even melt. Both lens and camera may sustain extensive damage, especially if you have left the camera unprotected from the sun. Direct rays can enter through the lens or viewer and, as rays work through a magnifying glass, burn a hole into the shutter curtain. Lubricants melt and ooze into places where they shouldn't be. Plastics soften and become gummy.

If there is nothing in the car to protect your camera, take your camera with you or leave it only momentarily. If it fits under the seat, it will be safer there. If not, select a shady spot on the floor. Try to find something to cover it with, such as a paper sack, newspaper, or road map. If you have a choice of parking spaces, choose a shady spot.

Whether you plan a short jaunt or a lengthy journey, take time to arrange protection for your camera and film. Insulated coolers, even an insulated diaper bag, work fine for a period of time. Frozen gel coolant should be added for longer protection. Freeze your film before any hot weather travel. Ziploc bags are ideal for freezing and travel. (I keep my extra film frozen or in the refrigerator anyway.) Squeeze out excess air before zipping. This gives added protection from ice crystals in the freezer or moisture buildup in the refrigerator. Film is like food; it

deteriorates. A film's emulsion is a gelatinous coating on a firm backing such as mylar. The emulsion contains light sensitive particles such as silver. When light strikes the film's surface, the silver forms an image. The silver particles not affected by light are taken away by the developing process. In the case of color film, the silver image is replaced by dyes in the developing process.

Film becomes out-of-date, which means it will produce a good image only within a certain period of time. Beyond the expiration date (the one stamped on the box) the image suffers. Heat hastens the aging process. The film will be ruined in a hot car within minutes unless it is protected.

Be sure to let frozen film warm up before putting it into in your camera. Trying to use such film immediately would be difficult and dangerous to both film and camera. The film and the camera's film plane can be scratched, and moisture will condense inside the camera and on the film. Allow the film to thaw slowly. To avoid condensation on the film surface, leave it in the unopened package, or canister, until the film reaches room temperature.

Never place a camera on the car's dashboard or on the rear window ledge. This is not only for the camera's protection but for your's also. A flying camera could be lethal in an accident. It is not a good idea for a camera to be loose anywhere in a car. Keep it, and yourself, protected. Car exhaust and gas fumes can be harmful. Placing cameras and film in trunks or over mufflers may cause them harm.

When I travel with my camera, I place my insulated cooler on several layers of newspaper behind the front seat. If I am driving, I put it behind the driver's seat; if I am a front seat passenger, I put it behind the passenger's seat. It is easier to have your equipment on the side of the car that you will be getting in and out of. The cooler contains packets of frozen Blue Ice and my frozen film packets. I place my camera bag, containing my camera and extra lenses, on top of the cooler and cover everything with the blanket. On top of the blanket a pillow with a white pillowcase reflects the sun's rays. When the Blue Ice is no longer cold I remove it from the cooler to make room for my camera and anything else that could be harmed by heat.

I wrap my camera and lenses in those thin, spongy, Styrofoam sheets used as shipping material, which protect and insulate. The blue, disposable bed protectors used in hospitals work well too. Experience will tell you just how long you can leave your camera before heat gets to it. If ever I am in doubt, I carry it with me.

In the winter the same cooler and bedding can be used to keep out the cold. Cold is not nearly as detrimental as heat, but cold can cause operational problems. The lubricants in a camera stiffen and batteries may not work properly. Do not use a camera until it has a chance to recover from the cold.

Besides serving as insulation, the bedding serves as camouflage. Leaving camera bags in a car in view of anyone passing by is an invitation to thievery. So is leaving them in a hotel/motel room unattended. If you are staying in a motel for just one night and you do not intend to use your camera, put it in the car's trunk (weather permitting); but do not leave it there for the next day's drive. If you leave your camera in a hotel room while you go out to eat, there is always the possibility that you might not find it there upon your return.

Traveling with Your Camera by Air

All of us know the reputation airlines have when it comes to losing luggage. If your camera is one that you would hate to lose, it is best to take it on board with you. Why burden your body with a heavy, bulky camera bag? Choose instead a lightweight, insulated bag. It will conform easier to airline regulations concerning storage under the seat. For added protection, wrap your camera in plastic bubble-wrap or the thin, Styrofoam sheets mentioned earlier. Another reason to keep your camera gear with you is that you know it will be handled gently. If you have ever observed the handling of luggage on airlines, you will know what I am talking about.

Place your film (exposed and non-exposed) in a transparent plastic bag (the old Ziploc again) and keep it in your carry-on luggage so that it can be inspected by security personnel. Do not put cameras, lenses, or film in the suitcase that will be checked. Refuse to allow your film to be

x-rayed. The airline people may insist that their x-rays will not harm film, and one exposure possibly may not. It depends on the type of film, the type of x-ray, and the intensity of the rays. Certain thin-base films may be harmed by one exposure; others may show fog after several exposures. The intensity of the x-ray may vary from one airport to another. Such x-rays have a cumulative effect, and several times through these devices may harm any film.

You may purchase a lead bag designed to prevent x-rays from penetrating the contents, but I hesitate to recommend it. Airlines may view the package as suspicious and increase the strength of the x-rays in an attempt to detect what is inside.

If you have any liquid, such as lens cleaner, be sure the cap is on tight and that the container is not subject to leaking at high altitudes. Place it in a Ziploc bag also, but not with your film. Before leaving check that everything is ready to be used. Are batteries fresh or have they been dying a slow death in an inactive camera? Do not forget those in the flash! It might pay to take extra batteries – those that are new, and not the same age as those in your camera. It is not always possible to shop in strange places.

Conclusion

For those whose minds are geared for technical details, there are many photography books that delve into the mathematical mysteries surrounding photographic processes. For those of you who do not want to go that far but are interested in going beyond the basics, consider the many good Kodak Company publications, including an excellent one on copying photographs. Kodak's *Master Guides* contain a variety of photographic dials and aids.

Keep up with "what's new" by reading photography magazines. The editors of *Modern Photography* magazine publish special issue magazines (annuals) called *How-to Guide* and *Photo Information Almanac*. I recommend both as excellent references. They should be available on newsstands. Search the shelves of your local library. There should be many good references, including *The Encyclopedia Of Photography*, published by the Graystone Press. Volume 6 has a comprehensive chapter on close-ups and copying.

Learning to do your own darkroom work is not difficult, should you be so inclined. It is a fascinating thing to watch pictures come to life in trays of developing solution. Making enlargements and trimming according to taste was the most fun for me. You may need to learn how to develop your own film and process your own prints if you find it difficult to find a photo lab that you are happy with. If you have access to the facilities of a custom lab, you might find it worthwhile to pay the extra cost for quality prints.

As it is with all things, there must be an end. I hope you have enjoyed this book and that it will be helpful to you. Only a genealogist knows the ups and downs that we experience in our research efforts, and the accompanying emotions. Why genealogy appeals to some and not to others

is as mysterious as a computer chip. Do genealogists have more than their share of curiosity, persistance, and patience? It certainly takes each of those qualities and more. Genealogy can be a consuming passion, and for many of us the passion will never cease. I am sure that there must be a stopping point at some time, but I am equally certain that we can never truly finish a family history. I chuckle inwardly at those who say that their's is *done, finished,* or *kaput.* I hope that mine is never finished. I'm enjoying it too much.

Index

References to illustrations appear in italic type.